IMAGES
of America

MEDFORD
THROUGH THE LENS

T0407372

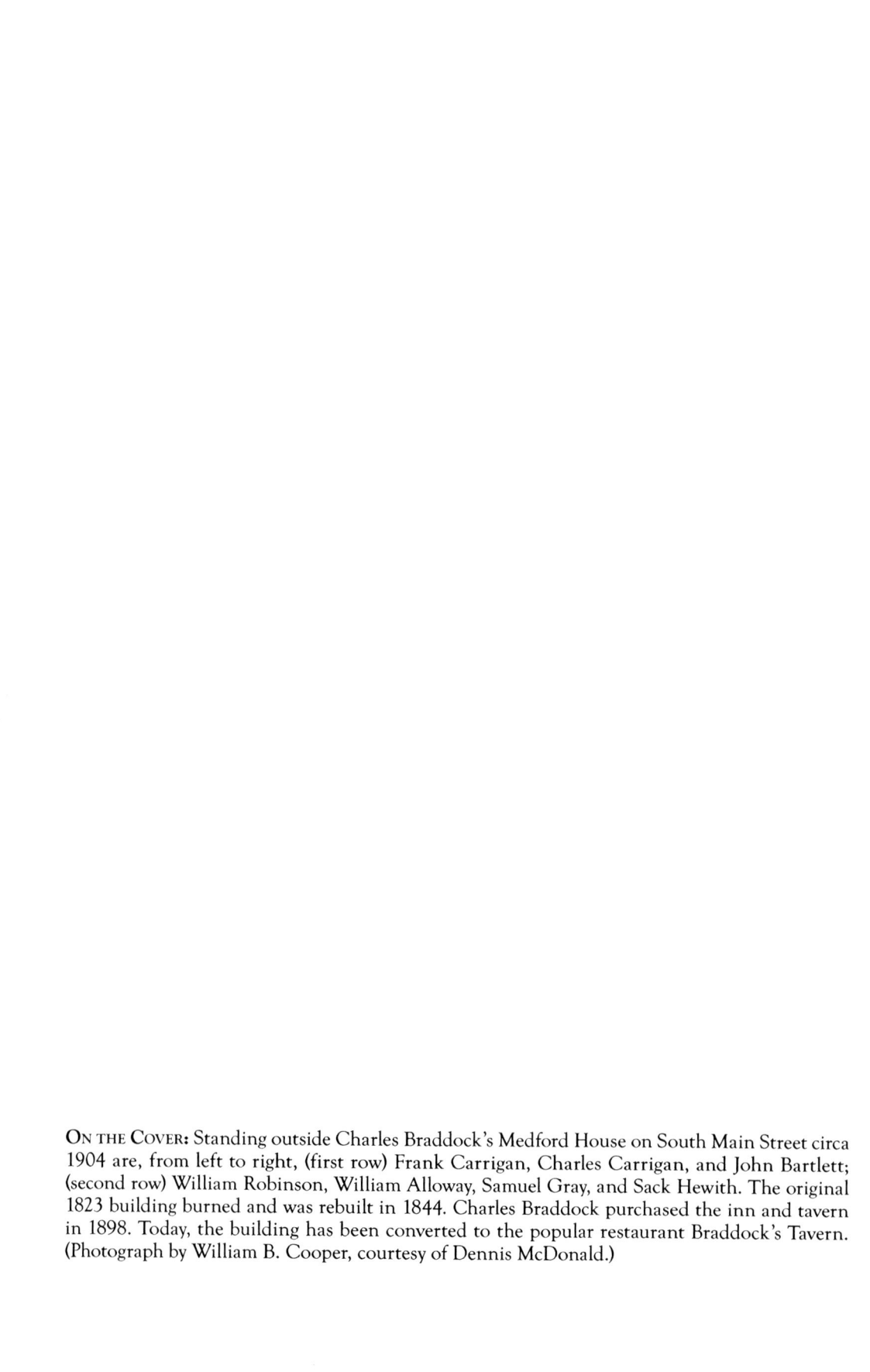

ON THE COVER: Standing outside Charles Braddock's Medford House on South Main Street circa 1904 are, from left to right, (first row) Frank Carrigan, Charles Carrigan, and John Bartlett; (second row) William Robinson, William Alloway, Samuel Gray, and Sack Hewith. The original 1823 building burned and was rebuilt in 1844. Charles Braddock purchased the inn and tavern in 1898. Today, the building has been converted to the popular restaurant Braddock's Tavern. (Photograph by William B. Cooper, courtesy of Dennis McDonald.)

IMAGES
of America

MEDFORD

THROUGH THE LENS

Dennis McDonald and Zachary Baer
Foreword by Ed Gager

ARCADIA
PUBLISHING

Published by Arcadia Publishing
Charleston, South Carolina

Printed in the United States of America

Library of Congress Control Number: 2024938206

For all general information, please contact Arcadia Publishing:
Telephone 843-853-2070
Fax 843-853-0044
E-mail sales@arcadiapublishing.com

Visit us on the Internet at www.arcadiapublishing.com

Dennis and Zachary would like to thank the people of Medford who opened their doors and taught us about the town's history.

CONTENTS

ACKNOWLEDGMENTS

This book was supported by many individuals and organizations. The Medford Historical Society and its volunteers, John Hines, Kelly Maguire, and Pres. Richard Bucko provided access to the society's extensive collection.

We are indebted to many individuals for sharing their knowledge and resources. Edmund R. Gager is an invaluable source of Medford history; we are grateful that he wrote our foreword. Eminent South Jersey historian Paul W. Schopp not only provided access to rare postcards and photographs that enhanced this work but also offered expert knowledge while editing the book.

Additionally, we are grateful for those who provided access to private photographic collections. Brian Carns, steward of the Everett and Beverly Mickle Collection, opened his home as we scoured his rich array of images. Joan Todd Lewis, Leon Todd's granddaughter and the first female president of the Medford Lakes Colony, answered questions and provided photographs. Former Medford Lakes resident Jody Rivera (née Merkh) and her husband, Mike, enriched our understanding of Medford Lakes and provided photographs. Thank you each for your support.

A very special thanks to realtor Carol Latti, Medford Friends Meeting clerk Davis Henderson, Camden County Historical Society library director Bonny Beth Elwell, Museum of American Glass (Millville) collections manager Dianne Wood, Quoexin Cranberry Company owner Thomas Gerber, Medford Company Store owner Mark Scherzer, YMCA of the Pines CEO Greg Keresztury, graphic designer Matthew Baer, and everyone at the Cedar Run Wildlife Refuge, including Jeanne Woodford, Mike O'Malley, and Tracey Bloodworth. We would also like to thank the late Clint Alexander, Brian Anderson, Bill Frame, the late Peter Hamilton, Jen Heicklen, Christian Hockenberger, Christine Lorenz, Paige McGregor, Michael McCormick, Debbie Nichols, Marc Sonsini, Ted Steinmetz, Richard Watson, Ken Middleton, Thomas Haunton, Wendy Entwistle, Lois Ann Kirby, Mark Demitroff, Millie Linett, Danielle Camilli, and Frank Jacobs III.

Zachary Baer would like to extend gratitude to his parents, Robin and Tim; brothers, Matt and Tyler; grandparents; wife, Katie; and his Shawnee High School coworkers and students for their support. Dennis McDonald would like to thank his wife, Rose Shields, and their extended family for their support.

INTRODUCTION

I have always loved Medford. As a teenager in the 1960s, my brother and I rode our bikes from Cherry Hill to Kirby's Mill to rent canoes. In 2006, my wife, Rose, and I moved to Medford, and I quickly developed a deeper interest in its history.

To learn more, I spent hours researching. I felt compelled to share my findings in a book that would explore Medford through photographs. Considering my educational and career path as a photographer, this seemed an appropriate medium. Years of research resulted in *Medford*, published in 2012 by Arcadia Publishing.

Throughout the process, Medford's community was extremely supportive. I enjoyed listening as they shared their stories and photographs. Beverly Mickle was among the most gracious of benefactors. For decades, she and her husband, Everett, acquired photographs and cultural ephemera. Among the unique items the Mickles shared was a series of glass-plate negatives from neighbor William B. Cooper. While I inserted some of Cooper's scenes in my first book, many excellent images remained unpublished.

Cooper's photographs, combined with others that the community provided, served as the inspiration for *Medford through the Lens*. In 2022, I asked Shawnee High School teacher and historian Zachary Baer to work with me as a coauthor; I am elated he agreed.

Medford through the Lens is first and foremost about Medford, a community in which history has always played a crucial role in its identity. The indigenous peoples first occupied the land, followed by members of the Religious Society of Friends, or Quakers. Today's Medford resulted from those now passed. As each chapter demonstrates, Medford serves as a microcosm of many historic events and themes important to American history.

Equally, *Medford through the Lens* is about why we remember the past. Medford residents, like residents of all communities, must know its history to ensure its future. This book focuses on such themes including education, community development, and Pine Barrens culture and conservation. We hope this book will inspire a critical examination of the past and provide a springboard for telling new stories in the future.

—Dennis McDonald

FOREWORD

Medford, what a great place to be born and grow up in! I was born in 1940 on a small farm on Stokes Road (now Spott's Hardware). At one time, our farmhouse was the First Methodist Church of Medford, located on Branch Street before it was moved to my parents' farm in the 1850s. I was delivered by a midwife. Years later, she told me: "Some of these doctors get too fancy delivering babies when all you need is a 'tater' knife."

My childhood was one that is filled with happy memories. On the farm, I lived with my mom, dad, grandmom, three brothers, and two sisters. We had a few chickens, a cow named Susie, a horse named Cheyenne, a dozen or so hogs, and 20 fox hounds.

When it came time for me to start school, I thought all schools were like the one-room schoolhouse that I could see from our kitchen window. My dad attended that one-room schoolhouse, known as the Cross Keys School. It has been restored and is on Mill Street in Medford.

So it was quite a surprise when I saw the Milton H. Allen School for the first time. When I attended, it was the only school in Medford. My teachers received their education at a two-year program from the Trenton Normal School. They were great, and I had the utmost respect for every one of them. Several of them were members of the Society of Friends, as were many of the town leaders.

Years later, after I wrote a book about the Gager family, I gave a copy to my eighth-grade teacher. I signed it "To Byron Eskra, a Teacher Extraordinaire." He loved history and was one of my favorite teachers.

Also, I attended the Baptist Sunday school in town, and I still have the Bible given to me by Abe Mortimer. He would be happy to know that his prayers were answered. Far from perfect, I'm a full-fledged Bible-believing Christian.

In those days, kids fished and swam anywhere they wanted. The Minnie Hole (located behind Bunning Field) was the most popular swimming spot in Medford. My uncle Leon Gager was the police chief of Medford Lakes for 40 years. Often, he would bring tags so we could swim in their lakes.

We rode bikes and our horse on mostly dirt roads or on trails we made through the woods. We played baseball in someone's backyard. When I got older, I could go coon hunting with my uncle Billy.

In Medford and Medford Lakes, the ponds and lakes were frozen solid from January through February, so ice skating was the main activity in the winter. I remember the great times we had building bonfires on Ballinger Lake.

We all had chores to do. I thought it was something when my brother Lee taught me how to milk Susie, which was one of his chores. I soon found out why he was teaching this to me. His job became mine.

Going to town on a Friday night was a big deal. Medford was a busy place, and it had the only traffic light in the township. Farmers were cashing their milk checks, and all the stores were open. Their wives would shop for the week's groceries and maybe stop into Thelma Robinson's ladies clothing store. A few of the farmers were still coming to town in horse-drawn wagons.

On Friday night, I felt fortunate to have 25¢ to go to the movies on Friends Avenue. If I had another quarter, I could get popcorn and a soda.

Being in the Boy Scouts was another happy memory. Ephraim Tomlinson, a former mayor of Medford, was the Scout leader. That's where I learned to swim.

Living down the street from Tip-Top Stables, I soon became enamored with those majestic creatures. The man who owned the stable had a tremendous effect on my life. Bill Loeffler was a man of faith and integrity and was an excellent horseman. I soon got an afterschool and summer job at the stable. One time, he took me to Sappy's store (at the intersection of Church Road and Route 541) for an ice cream cone and gave me 15¢. He went on to say that he would have vanilla and chocolate. That meant I got one scoop.

Speaking of Sappy's, another memory remains indelible in my mind. One hot evening, my dad, Ralph, bought 40 quarts of ice cream on sale from Sappy's. About a week later, pop decided to have a dish of ice cream. Well, you could have heard him a mile away when he found out there was none left. All of us kids were inviting our friends over for ice cream parties on a daily basis. It was served in soup bowls. Grandmom Nettie was in on every sitting.

One winter, Mr. Loeffler went away for a few days and left me in charge of the 17 horses in the stable. Lo and behold! I let the hand-pump freeze, and I had to carry 17 buckets of water to the horses that night and the next morning from the creek right next to where Riviera's is today. I told my dad, and he said I was the dumbest boy he had. However, he immediately installed a brand-new pump. He loved his children and would do anything for them.

Pop was a plumbing and heating contractor, and he and my mother, Josephine, owned a hardware store in Medford. I hated doing inventory in the bolt room and counting cans of paint, but mom was not to be reckoned with. Come to think of it, when my sister Joyce got her license, she took all of us for a ride in mom's new car. She hit a tree and dented the car. We decided to tell mom that Joyce swerved to miss hitting a dog. Mom took each one of us separately to ask about the dog. We all told her about different kinds of dogs. Needless to say, Joyce's driving privileges were suspended for quite a while.

From the time I can remember, our pantry was filled with all kinds of food. With six kids to feed, canned food was bought by the case. Mom put up tomatoes and all the fruits that were in season. I remember catching chickens for mom to roast for dinner. Grandmom Nettie made homemade bread every week. It was delicious, and to this day I have never tasted better. Unfortunately, she had no recipe; it was all in her head. Oh, how we loved her and that bread.

Later on, my mother opened an antique shop in town. She was also a member of the Daughters of the American Revolution and an avid genealogist. She was the one who got me interested.

I am in the sunset of my life and thankful for the fond memories of yesteryear. At 83, I wish I could remember the present as well as I can the past.

As far as my life is concerned, I think the best decision I've ever made was marrying a Medford girl. I've known her since she was five. This year, we celebrated our 61st wedding anniversary.

—Edmund R. Gager

Medford Historical Society trustee Ed Gager speaks about the town's history to fifth-grade students. In his hands is a basket made by Indian Ann (1804–1894), a famous weaver from Indian Mills, Shamong Township. He donated the basket to the Medford Historical Society. Gager frequently speaks to groups about the history of Medford and Medford Lakes. (Courtesy of Ed Gager.)

One

WILLIAM B. COOPER

Born in 1864 in Chester County, Pennsylvania, William Brinton Cooper worked an array of occupations throughout his life but was always self-employed. He labored as a roofer and plumber early in his career. While laying a water main in 1896, an embankment cave-in injured Cooper and caused a coworker's death. Soon after the incident, he concentrated on running a hardware store as sole proprietor, then with a partner, then alone again. Near the end of his career, he operated a garage and serviced automobiles. Cooper served on the Medford Board of Education and the Election Board, and he was appointed as a Medford substitute mail carrier in 1911.

His 1942 obituary mentions his activities with the water company board, the fire company, and the Masonic lodge and his enthusiasm for the Medford Board of Trade. It states that his hardware store hosted the first telephone in town in 1899 on South Main Street. He travelled to Lincoln, Nebraska, in 1891 to marry Margaretta Jane Crawford. The newlyweds returned to Medford, and the marriage produced three children: Eleanor, Watson, and Mary.

Nowhere does it mention, other than on the 1910 Federal Census and on a Burlington County Petit Jury form in 1915, his work as a photographer. While it is unclear how long Cooper worked as a photographer, it was a short period of time, perhaps 15 years. His business entailed photographing people, street views, businesses, and different groups, like the Medford Religious Society of Friends, thereby capturing everyday life in Medford. From his photographs, we learn about workers at Star Glass, churches, schools, how people played, and the look of Main Street. Cooper also traveled by train to other towns along the rail lines or by automobile to capture life in those communities. He produced contact prints of his images on postcard-backed photographic paper and sold the views to local stores.

Armed with a large format camera and glass plates, he brought life to this small piece of America in the early 1900s. The authors owe much to William B. Cooper. His work lives on throughout this book.

The Cooper family sits for a self-portrait in their Bank Street home around 1910. From left to right are William, Margaretta, Watson, Mary, Eleanor, and Mary Cooper Stokes (William's sister). William took the photograph with a bulb-release mechanism he held in his left hand. Cooper often used members of his family in photographs. Below are his wife and two daughters in a boat on Haines Creek. (Both photographs by William B. Cooper, courtesy of Brain Carns from the Mickle Collection.)

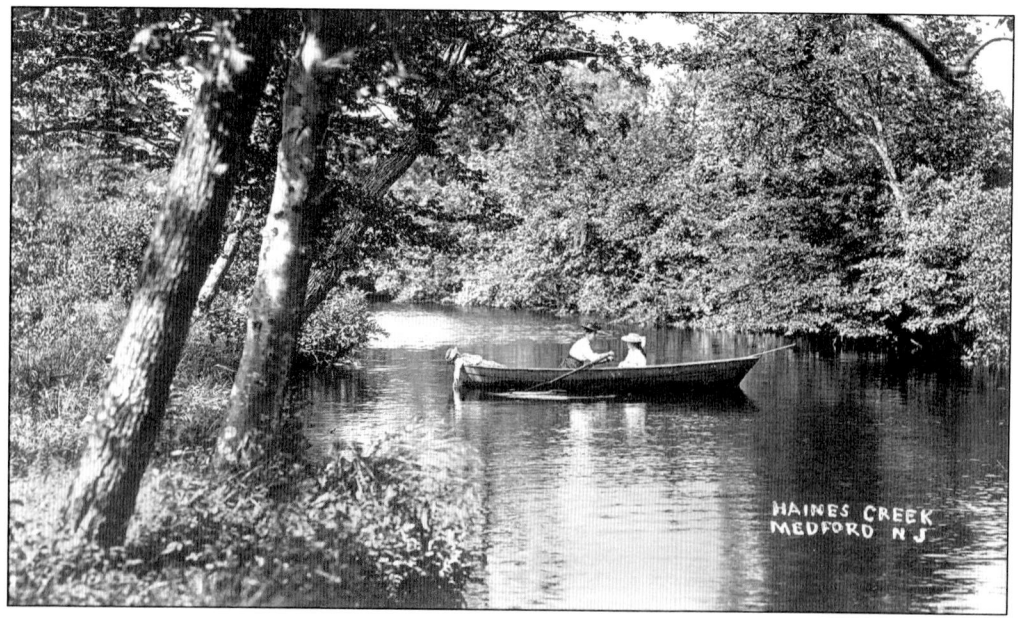

Playing dress-up are, from left to right, Eleanor Cooper, Bertha Friend, and Mary Cooper with the parasol. Bertha Friend is the mother of Beverly Mickle. Beverly and Everett Mickle collected photographs of Medford and preserved much of Medford's early history. (Photograph by William B. Cooper, courtesy of Brian Carns from the Mickle Collection.)

The Cooper children, from left to right, Watson, Eleanor and Mary, are photographed at the remains of the sawmill at Oliphant's Mill, located at the end of Mill Street, formerly Oliphant's Mill Street. There was also a gristmill located onsite operated by David Oliphant and his descendants for more than 90 years. (Photograph by William B. Cooper, courtesy of the Allen School Collection.)

Photographed at the Philadelphia, Marlton & Medford train station in 1905 sits engine no. 186, a D7-class 4-4-0 American-type locomotive constructed at the Pennsylvania Railroad's Altoona Machine Shop in 1889. Train engineer Eli Thomas is inside the cab, and conductor Chris Shingle stands beside the cab at the North Main Street station. Coachman Howard Homan sits with his horse-drawn carriage and passenger outside the station. According to research by Paul W. Schopp,

the paving bricks and dirt in the foreground indicate that the West Jersey and Seashore's Bridge and Building gang was preparing to lay down hardscape paving on the platform, making it safer and cleaner for the passengers. (Photograph by William B. Cooper, courtesy of Dennis McDonald from the Mickle Collection.)

This country farmhouse, located on the north side of Chairville Road, was photographed with owner Wilbert Engle, his wife, Ella, and their daughter Esther in 1910. Engle farmed potatoes and strawberries on his land but was known throughout Burlington County as a cattle expert. (Photograph by William B. Cooper, courtesy of Dennis McDonald from the Mickle Collection.)

While waiting for the arrival of a train (the blur in the background), members of the Citizen's Military Band of Medford, led by Professor Garrecht, stand on the platform of the Philadelphia, Marlton & Medford station on North Main Street posing for the photographer. The band was travelling to Millville, New Jersey, to perform in a parade in 1908. (Photograph by William B. Cooper, courtesy of Brian Carns from the Mickle Collection.)

The Burlington County National Bank served Medford for 144 years before it was absorbed by a larger bank in 1981. Seen in the early 1900s, it was located at the intersection of South Main Street and Bank Street. At left is the Medford Variety Store, with Israel Cohen as proprietor. At right is the drugstore run by Henry P. Thorn, who was also the bank president. (Photograph by William B. Cooper, courtesy of Dennis McDonald from the Mickle Collection.)

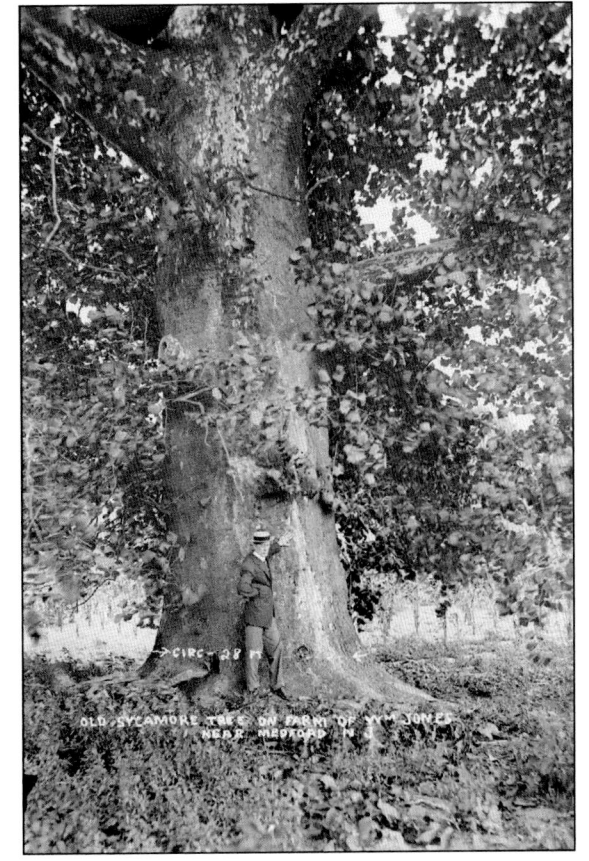

A giant sycamore tree located on the William Jones farm, near the intersection of Church and Hartford Roads, is pictured with an unidentified man at the base of the tree for size comparison in 1910. A newspaper at the time reported the tree measured "over 24 feet in circumference at the height of a man's head." The approximate age of the tree at the time was 250 years old, and it might have been planted in the mid- to late 1600s. (Photograph by William B. Cooper, courtesy of Dennis McDonald from the Mickle Collection.)

The Indian Chief Tavern stood at the corner of North Main and Union Streets for over 100 years. It served as a stop for travelers coming by carriage between Burlington and Mount Holly and many shore destinations such as Tuckerton. The stables were located in the rear of the building, and a barbershop was located in the building at left on Union Street. (Photograph by William B. Cooper, courtesy of Dennis McDonald from the Mickle Collection.)

Nearly 500 members of the Medford Friends Meeting gathered for lunch in the shade during the 100th-anniversary celebration of the meetinghouse on Union Street in August 1914. Quakers first settled in Medford in the late 1600s. The meeting hired William B. Cooper to document the event and used many of his photographs in its 100th-anniversary publication. (Photograph by William B. Cooper, courtesy of Dennis McDonald from the Mickle Collection.)

This treeless view of the east side of North Main Street was taken in 1915. The last three houses on the left belonged to Albert Kirby (89), Maurice Haines (85), and Everett Haines (83). The house at 73 North Main Street, at right, was the home of Ralph Durr, president of the Burlington County Bank. The view of the street has not changed in more than 100 years except for the street's arborous appearance. (Photograph by William B. Cooper, courtesy of Dennis McDonald from the Mickle Collection.)

This view of Union Street looks east toward Main Street and shows a dirt road with sidewalks, curbs, and hitching posts in front of the houses around 1910. This section of Union Street in Medford was the beginning of the main roadway to Camden's waterfront and Philadelphia's marketplace. In the morning, farmers and drivers crowded the road as they carried their products to market. (Photograph by William B. Cooper, courtesy of Dennis McDonald from the Mickle Collection.)

A postcard shows ornithologist and botanist Witmer Stone's cabin on the Rancocas Creek. Stone stayed there while exploring the Pine Barrens. As a result of his decade-long travels throughout the pinelands, he wrote the book *The Plants of Southern New Jersey*, published in 1911. In 1927, the Arch Street Friends Meeting in Philadelphia purchased the cabin and surrounding area to use as a camp. The cabin still stands in its original location as part of Camp Dark Waters. (Photograph by William B. Cooper, courtesy of Paul W. Schopp.)

This photograph shows Bank Street looking east from the intersection of Charles Street. This street is one of the principal residential side streets of Medford Village. Residents began constructing their houses in the 1820s. The brick house at right is the first house on Bank Street, built in 1827 by Jacob and Mary Prickett. (Photograph by William B. Cooper, courtesy of Dennis McDonald from the Mickle Collection.)

The Medford Water Company was established in 1895 after a disastrous fire destroyed Taylor's General Store on Main Street. Afterwards, the water company dug a water main along Main Street with intermittent fire hydrants to allow quick access to water. The vertical water tower was located on Mill Street, and the cement base is still there. The pumphouse was located behind the water tower at the Rancocas Creek. (Photograph by William B. Cooper, courtesy of the Medford Historical Society from the Mickle Collection.)

In the early 1900s, photographers were allowed on the field to capture baseball game action. Cooper stood on the field of the Medford Field Club, located on the west side of North Main Street above Firehouse Lane. The baseball field was close to both railroad stations serving Medford. Visiting teams and supporters traveled to games by train in the late 1800s and early 1900s. The game ended before the last train left town. (Photograph by William B. Cooper, courtesy of Dennis McDonald from the Mickle Collection.)

A panoramic view of the activity at Kirby's Mill looking east on Church Road shows piles of cut lumber awaiting shipment to local lumberyards and as far as Philadelphia and Baltimore. Built in 1778, William S. Kirby purchased the mill from the Haines family in 1877. The Kirby's Mill complex contained a sawmill, a gristmill, a blacksmith shop, a wheelwright shop, and later a cider mill. When

the Medford Historical Society purchased the partially operating mill from the Kirby family in 1969, it was the last operating commercial mill in New Jersey. It is now the society's headquarters. (Photograph by William B. Cooper, courtesy of Dennis McDonald from the Mickle Collection)

One way William B. Cooper made money from his photography business was by teaming up with local businesses. Cooper photographed house painters Walter McClain and William Griscom standing outside houses they painted after their work was completed. Above, Griscom (left), next to the "House Painters" sign, and McClain stand outside their paint shop on Bank Street. Below, they both stand outside 9 South Main Street, the former home of Isaac Stokes. (Both photographs by William B. Cooper, courtesy of the Medford Historical Society.)

House painters Walter McClain and William Griscom used Cooper's photographs to make real photo postcards. The painters wrote the name of the owner or the name of the famous person who formerly lived in the home and mailed the cards out to potential clients, showing their work through photographs. Local newspapers also ran mentions in Town Brief sections that a well-known person just had their house painted. Above is the home of Jay Bowker on Bank Street. Below is the home of John Mingin on South Main Street. (Both photographs by William B. Cooper, courtesy of the Medford Historical Society.)

When a newsworthy event happened in Medford, William Cooper was often there. Like today's photojournalists, Cooper covered sports, features, and breaking news. In this instance, Cooper photographed the result of a steam tractor breaking through a wooden bridge over the Rancocas Creek at Kirby's Mill in 1907. (Photograph by William B. Cooper, courtesy of Brain Carns from the Mickle Collection.)

The Cooper home was located on the southeast corner of Bank and Filbert Streets. Standing on the porch are William Cooper's wife, Margaretta (left), and his sister, Mary Cooper Stokes (right). Playing in the yard are the Cooper children, Eleanor (left), Mary, and Watson, who is riding a tricycle. (Photograph by William B. Cooper, courtesy of Dennis McDonald from the Mickle Collection.)

Two

SCHOOLS

Medford boasts a rich history of educational institutions. The Religious Society of Friends established the Union Street School, the first in the Medford area, circa 1760. The Oak Grove School, located near the current Stratton Cemetery, was built in 1791.

During the first half of the 1800s, Medford residents, often with the aid of Quakers, established at least eight schools. Five were one-room schoolhouses at which the rural population paid tuition for attendance. These included the Brace Road School, the Eastern School, the Chairville School, the Fostertown school, and the Cross Keys School.

In addition, three private institutions existed: the Hicksite Friends' South Street School, located in downtown Medford; a boarding school for children throughout southern New Jersey, which opened some time in the late 1850s; and a tuition-based school on Church Street operated by the Methodist Church during the 1800s.

In 1860, Medford school superintendent Joseph Evans wrote a grim report of Medford's schools. Beyond his feeling that more schools should be free to attend, he reported that Medford residents lacked "a deeper interest in their educational affairs." This changed in 1867 and 1871, when the state passed laws mandating children ages five and older attend school for at least 180 days. Enrollment consequently surged, causing the district to consolidate and build the Filbert Street School, also known as the Medford School, which remained in use until the late 1920s, when the Milton Allen School replaced it.

Post–World War II suburbanization saw Medford's population almost quadruple, increasing from 2,836 people in 1950 to 8,292 in 1970, necessitating new schools. Medford partnered with nearby towns to create the Lenape Regional High School District (LRHSD) in 1956. The opening of Lenape Regional High School in 1958 allowed Medford students to attend a high school in town for the first time since the Filbert Street School's closure. As the postwar population boomed, Medford Township opened Haines School in 1961 and Medford Memorial in 1968. The LRHSD soon followed, opening Shawnee High School in 1970.

NOTABLE SCHOOLS IN MEDFORD, NJ

1. Brace Road
2. Burlington County Institute of Technology
3. Chairville (Hampton)
4. Cranberry House
5. Cross Keys
6. Eastern
7. Filbert Street
8. Fostertown (Northern)
9. Haines Mill (Kirby's Mill)
10. Lenape
11. Medford Memorial/ Haines 6th Grade
12. Methodist
13. Milton Allen
14. Oak Grove
15. Samuel Smith Boarding
16. Shawnee
17. South Street (Hicksite Friends)
18. St. Joseph's/St. Mary's
19. Union Street Friends

DOWNTOWN MEDFORD

Designed by Matthew Baer, 2024

This chapter references many schools that no longer exist in Medford Township. Use this map to situate the schools near their approximate location. The map was created by combining numerous historic maps of Burlington County, including but not limited to the 1849 Otley and Whiteford map, the 1859 Parry, Sykes, and Earl map, and the 1876 J.D. Scott atlas. Medford's border was much larger in the past. The township ceded land to Shamong in 1852, Lumberton in 1860, and Medford Lakes in 1939. (Map by Matt Baer.)

The Religious Society of Friends established the first school in Medford, the Union Street School, around 1760. This image from 1889 depicts the schoolhouse in the foreground and the meetinghouse in the background. Students can be seen sitting on the steps. (Courtesy of Davis Henderson.)

The Fostertown school is shown in the early 1900s. Fostertown was part of Medford until 1852. Very little information exists about the founding of the Fostertown school beyond a reference to the school in annual reports. During the 1880s, the school maintained a female teacher earning $26 per month and provided education for about 10 months of the year, educating approximately 50 students. (Courtesy of Brain Carns from the Mickle Collection.)

The century-old Cross Keys School is pictured in the winter of 1958 while serving as a private residence. The truck is lettered for A.J. (Allen John) Wilkins on the driver's-side door. According to town tradition, in the mid-1800s, local residents constructed the Cross Keys School at the intersection of Stokes and Dixontown Roads, naming it after the local tavern of the same name. (Courtesy of Brian Carns from the Mickle Collection.)

The abandoned Cross Keys School sat on the corner of Stokes Road and Dixontown Road. The school officially closed in 1927. In 1975, Medford Police public safety officer Russel Hargis devised a plan to move the school for the Bicentennial. The police department volunteered to prepare the school for transport by removing the roof and any exterior attachments. Once moved, the police renovated the school with a new roof, chimney, plaster, and paint. (Photograph by Harry Oakes, courtesy of Laurie Oakes Chranowski.)

The Cross Keys School was transported in April 1976 to its currents site on Mill Street. Today, a McDonald's sits at the school's former location. A 1979 *Courier Post* article titled "No Taste for Big Macs" noted that Medford residents protested McDonald's attempt to build a restaurant in town. After the zoning board denied McDonald's, the corporation sued. In 1980, a judge ruled in favor of McDonald's, and the restaurant was constructed. (Photograph by Harry Oakes, courtesy of Laurie Oakes Chranowski.)

Alumni of Medford's one-room Cross Keys School reunited in May 1982 to have their photograph taken for the *Burlington County Times* at the new location on Mill Street between the Haines Sixth Grade Center and the Medford Middle School. From left to right are Geneva Shontz, Ethel Merefield, Edna Sutton, Ruth Lemley, Louis Shontz, and Evelyn Foulk. (Photograph by Dennis McDonald, courtesy of the *Burlington County Times*.)

This school portrait, an example of tintype photography featuring teacher Lizzie Carmelia, is believed to be at the Eastern or Kirby's Mill School, located on the east side of Kirby's Mill. The Eastern/Haines Mill/Kirby's Mill School maintained at least two school buildings in this vicinity. In a 1914 vote held to decide whether to shutter the aging schoolhouse, a 28-0 unanimous decision allowed the school to remain open for another four or five years. (Courtesy of Brian Carns from the Mickle Collection.)

Students at the Eastern/Kirby's Mill School pose for a class portrait in 1908. From left to right are (first row) unidentified, William Rodgers, Albert Rodgers, unidentified, Garret Lewis, Floyd Lewis, unidentified, and Alfred Miller; (second row) Raymond Prickett, William MacIntosh, William Miller, and Clifford Pew; (third row) Clara Worrell, Blanche Willitts, Miriam Prickett, Virginia Atkinson, Wilhelmina Carrol, Marion Worrell, Gertrude Pew, and Matilda Fisher; (fourth row) Sadie Miller, Hattie Pew, Florence Alloway, and teacher Sarah K. Davis. (Courtesy of Dennis McDonald from the Mickle Collection.)

No photographs exist of the first Oak Grove School. According to Burlington County school superintendent Edgar Haas, Enoch Stratton bought land on Stokes Road near the intersection of Himmelein Road to build the school. It opened around 1791, making it purportedly Medford's first public school. In 1852–1853, Dudley Ballinger, Samuel Thackara, and Isaac Glover financed a new school closer to Cross Keys. (Courtesy of the Library of Congress.)

The Brace Road Schoolhouse was constructed in the early 1800s and was still standing in the early 1900s. The one-room school served those living at Cross Roads, including Dr. James Still, who attended in 1832, 1833, and 1834. According to research by Paul W. Schopp, Robert Evens and Delia (Delilah) Johnson established the first African Methodist Episcopal congregation in Burlington County and held services in the Brace Road Schoolhouse around 1820. (Courtesy of Brian Carns from the Mickle Collection.)

An increase in student population due to the passage of compulsory education laws forced Medford to construct a new school. The 1876 annual school report notes that Medford "through the liberality of their people, erected, at a cost of six thousand dollars, a new, large and tasteful edifice capable of accommodating all their children." This school photograph was taken at the Filbert Street School or Medford School in 1896. A young Howard Friend is seated third from the left in the first row. (Courtesy of Brian Carns from the Mickle Collection.)

Mae Ballinger (Novelle) poses with her first-grade class at the Filbert Street School in 1918. Mae is fifth from right in the back row with short hair and a neckerchief. Note the poster on the front door advertising War Savings Stamps to support the United States during the First World War. (Courtesy of Mae Ballinger Novelle.)

Two undated photographs depict "upperclassmen" at the Filbert Street School. Above, middle-grade students stand with their teacher. The photograph below shows Cliff Prickett, Evelyn Stackhouse Belcher (left of teacher) and Clarence Mickle. Initially, the Filbert Street School served students through middle school. In 1889, the school divided a classroom on the second floor to make room for a two-year high school. In 1907, an addition was appended to the school to accommodate a three-year high school program. (Both, courtesy of Brian Carns from the Mickle Collection.)

In 1913, the Medford high school graduation comprised only two students. During the 1910s, Medford residents battled with the board of education to keep the high school open but lost. When the school closed, students rode the Pennsylvania Railroad to Mount Holly or Haddonfield for high school. (Photograph by William B. Cooper, courtesy of Dennis McDonald from the Mickle Collection.)

In September 1977, Burlington County opened the John K. Ossi Vocational-Technical School, now known as the Burlington County Institute of Technology (BCIT). Ossi, pictured here during the dedication ceremony, served as the county superintendent of schools for 15 years. In its first year, the $9-million school served about five hundred ninth- and tenth-grade students from 13 school districts. Students received instruction in 23 skill areas. (Photograph by Dennis McDonald.)

Eighth-grade students pose for a class portrait at the Milton H. Allen School in 1939. Principal Elizabeth "Bess" Cowperthwait can be seen in the middle of the back row. Her retirement in 1939 makes this one of her final photographs with students, a fitting end to her 35-year career in education. In her final year as principal, she made $1,600, half of what her brother made working at the post office. (Courtesy of Brenda Parks Morris.)

Kindergarten students pose for a photograph in front of the Milton H. Allen School in 1942. Some of the surnames include Huston, Cosaboon, Barnes, Durham, Webb, Haines, Gager, Jacobson, Hewitt, Lister, Sweet, Reilly, Milich, Palmer, and Gaskill. The township commemorated Milton Allen, a former teacher and principal in Medford, by naming the school in his honor. The school's construction reportedly cost the township $145,000. The school remains in use today, serving prekindergarten through the fifth grade. (Courtesy of Ed Gager.)

The Lenape Regional High School District formed in 1956 and soon after purchased 53 acres from Jacob J. Tiver and Edwin Ingling. Lenape opened in 1958. The school served 600 freshmen and sophomores with room for 1,000–1,200 students. Members of the community praised the school's modern amenities. As the *Courier Post* wrote, "It's new, it's modern, it's Lenape Regional High School." (Courtesy of the Lenape Regional High School District.)

In a typical morning scene, students descend the steps of the bus and enter the new Lenape High School. Teenagers from Medford, Medford Lakes, Mount Laurel, Tabernacle, Southampton, and Shamong attended the school. Legendary secretary of Lenape High School Mary Jane Mullen attended the school upon its opening and graduated in 1961. She spent 61 years at the school. (Courtesy of the Lenape Regional High School District.)

As the first wave of baby boomers became teenagers, districts like Lenape Regional scrambled to make classroom space. In 1961, Lenape held double sessions to accommodate 1,500 students. Sophomores through seniors attended classes from 7:25 a.m. to 12:46 p.m., while freshmen attended from 12:30 p.m. to 5:19 p.m. A $665,000 addition ended split sessions. This photograph from the 1962–1963 yearbook shows Lenape's cheerleaders in the gymnasium. (Courtesy of the Lenape Regional High School District.)

As the school population doubled over a five-year period, Lenape Regional required a second addition costing $1.5 million. Opened in 1965, the new wing included 34 classrooms to accommodate 1,000 students. This image shows students and faculty passing under the walkway connecting the old upper-grade wing to the new lower-grade wing. (Courtesy of the Lenape Regional High School District.)

The Lenape Regional School District purchased 79 acres from the Beck family in 1967 to build Shawnee Regional High School. Construction started in 1968, and the school opened in 1970. As this photograph makes clear, the school remained unfinished as the students arrived for their first day in September 1970. (Photograph by Ted Steinmetz.)

Ted Steinmetz, a chemistry teacher at Lenape, transferred to Shawnee when the school opened and taught there until his retirement in 1998. Steinmetz was also a photographer, and the district flew him above the construction site to take this aerial photograph after the school's opening in 1970. (Photograph by Ted Steinmetz.)

Students at Shawnee High School change classes during the opening days of 1970. With the school still under construction, no bells or public address system existed. To signal the end of the 40-minute class period, a secretary used an aerosol-powered foghorn with a two-mile range. At the time, about 1,000 students attended the school. The school's official dedication ceremony occurred on October 31, 1971. Gordon Galtere, Shawnee's first principal, called the first year a "honeymoon phase" due to the cooperation between staff and students in the face of adversity. (Both photographs by Ted Steinmetz.)

This cranberry storing and packinghouse later became the Cranberry House School, located on the corner of Tomlinson Mill Road and Breakneck Road in Taunton Lakes. In the late 1960s, Ron and Kathy Hoffman purchased the derelict building and rehabilitated the structure to serve as a private and progressive school that had small classes and no grades. A conflagration engulfed the building in August 1975, shutting down the school. Note the sign "Blue Lake" on the gable end, indicating the location. (Courtesy of Mary Beth Myers.)

Members of the St. Joseph School safety patrol stand outside for a photograph in the fall of 1970. The school, which opened in 1954, was staffed by four Sisters of St. Joseph. The school changed its name to St. Mary of the Lakes in the 1980. Currently it serves prekindergarten to the eighth grade. (Courtesy of Mary Pat Myers.)

Three

MEDFORD GLASS COMPANIES

At its peak, the Star Glass Works, located on South Main Street from 1890 until 1923, was Medford's largest employer. Numerous sources confirm that the factory employed over 250 workers, including blowers, cutters, mold boys, and carrying-in boys, who worked over two shifts.

The glass industry in Medford had humble beginnings. The first business was reportedly a window glass factory around 1825. It was not until 1845 that the Medford Window Glass Factory became a viable business. On August 19, 1845, the *New Jersey Mirror and Burlington County Advertiser* reported that the factory's dedication included "the Glassborough [sic] Band performing, a full diner [sic] table and numerous speeches by the company managers, and more music 'till daylight the next morning.'" Shortly thereafter, want ads sought window glass cutters, and advertisements appeared in newspapers for Medford window glass throughout New England, New York, and Pennsylvania.

Over the ensuing decades, the Medford Glass Company changed ownership several times, producing bottles and glass tableware. William Porter acquired it in 1849. In 1860, Medford Glass Works changed its name to Cochran's Glass Factory. In 1863, C.B. Tice and Company purchased Cochran's Glass only to sell it in 1875 to Yarnell and Trimble. A few years later, an ad appeared in *The Philadelphia Inquirer* offering the Medford Glass Works for sale, including factory buildings, machinery, and dwellings.

In early 1890, the glass works sold for $1,000, giving rise to the Star Glass Company. Although management changed hands in its early years, control at Star Glass eventually settled under Pres. John Mingin, treasurer Frank Reily, and general store manager Samuel Garwood. This triumvirate oversaw its growth through the unionization of glass blowers in 1899 and the expansion into soda, catsup, whiskey flasks, and nursing bottles.

The Star Glass Works remained in operation beyond most other small Southern New Jersey glass factories. In 1923, however, wage disputes threatened, as did enforced child labor laws, while machine-made glass became the standard. Soon after May 5, Star Glass shut down for the summer and never reopened. Two months later, the factory was again advertised for sale, but no buyers came forward.

This February 9, 1846, Pratt and Rogers' Company advertisement of window glass from Medford, New Jersey, is one of the earliest mentions of the glass industry in town. The glass is described as having "a beautiful lustre, a good surface and it is fully equal in thickness to the Waterford." As a result, Medford window glass commanded a high price in the marketplace. Business growth at the glass works demanded additional skilled workers, as this 1846 advertisement in the *Philadelphia Public Ledger* demonstrates. (Above, courtesy of the American Museum of Glass, Millville, New Jersey; below, courtesy of *The Philadelphia Public Ledger*.)

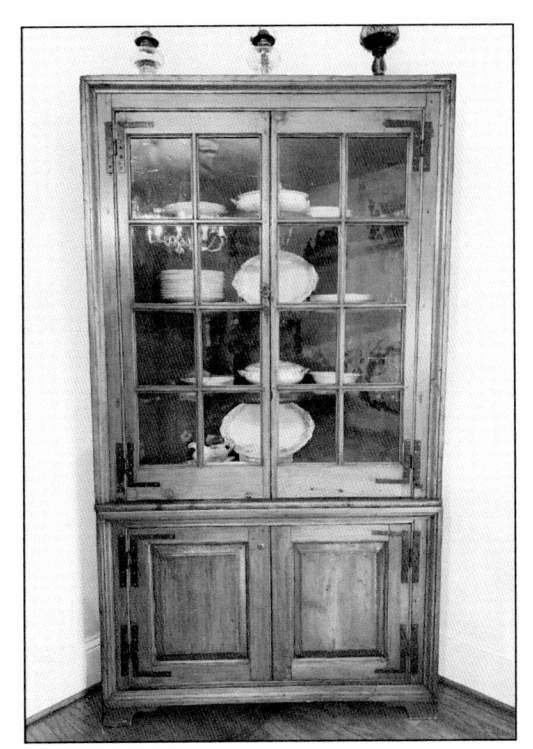

Medford carpenter Jesse Stackhouse fabricated this corner cabinet around 1870; it is now owned by Daryl and Edmund Gager. Stackhouse used all Medford materials in the cabinet, including the lumber, nails, and most importantly, Medford window glass. The stereo view photograph below, taken in 1873, shows men and boys standing outside the Medford Glass Works surrounded by crates of cullet (broken or waste glass) with a pile of glass slag in the background. The huge chimney remained standing long after the factory closed until a strong wind felled it in the late 1940s. (Right, photograph by Dennis McDonald; below, courtesy of the Mickle Collection.)

The Medford Glass Works produced this mold-blown half-pint amber flask with a pewter screw-top lid around 1875. At the time, Yarnall and Trimble owned the factory. They maintained a New York City office at 58 Murray Street (see the bottle cap image below). Also, the company exhibited a glass tank capable of holding 30 gallons at the Philadelphia Centennial International Exhibition in 1876, according to the *Monmouth Inquirer* of Freehold, New Jersey. The company had its main office in Philadelphia and had formerly operated the Milford Glass Works in Evesham Township, New Jersey. (Both, courtesy of the American Museum of Glass, donated by Frances Armentrout.)

The advertisement above, in the July 8, 1875, *Crockery Journal*, indicates that the Medford Glass Works of Medford, Burlington County, New Jersey, produced glass bottles of many different types. Yarnall and Trimble were the last owners of the Medford company before the business was put up for sale in 1887. The clear, small, long-necked bottle with a circular panel for a label was made at the Medford Glass Works. It is unclear who owned the factory at the time, but it was possibly blown during the C.B. Tice and Company tenure at the works after 1864. (Above, courtesy of Lois Ann Kirby; right, courtesy of the American Museum of Glass, donated by Josephine Gager.)

The 1915 Sanborn Fire Insurance Map of Medford, Burlington County, New Jersey, illustrates the Star Glass Company's complex, formerly the Medford Glass Works. Inside the factory walls was the company store, multiple storage and packing facilities, and two furnaces. The area, located south of the Rancocas Creek, is bordered by South Main Street on the east and Mill Street on the west. The southern border of the factory was Trimble Street, and beyond that, the village of Medford ended. Trimble Street featured factory-owned housing for the glass workers. This area surrounding the Star Glass Company was known by many names, including Glass Town, Glass Hill, and Skin Hill. (Courtesy of the Library of Congress.)

Mahlon Cotton drives a glass factory wagon on Branch Street at its intersection with North Main Street in 1905. The workers delivered glass products to Medford's train stations. On Friday, March 7, 1913, the Star Glass Company shipped seven railroad carloads of glass bottles to 18 different states. According to the *Camden Daily Courier*, this was the heaviest shipment ever made. (Courtesy of Mark Scherzer from the Mickle Collection.)

Star Glass Company employees assemble for a photograph outside the furnace building in the early 1900s. Workers moved from glass company to glass company throughout South Jersey depending on the work available. Star Glass employed more than 250 people at its peak. (Courtesy of Mark Scherzer from the Mickle Collection.)

Glassblower Hazleton Miller, left sitting in his chair, finishes a glass article at his workstation inside the Star Glass Company factory. He came to the glass company shortly after the Batsto Glass Works closed in 1867. He then traveled to Medford looking for work in the glass industry. Glassblowers at the Star Glass factory were known for their speed. Many blowers could produce hundreds of bottles in a shift. In 1899, while employed at Star Glass, Miller became the president of the newly organized local branch of the South Jersey Glassblowers' Association when the company unionized on September 17 after going on strike on April 10. His three sons also worked at the factory at different times. (Photograph by William B. Cooper, courtesy of Dennis McDonald from the Mickle Collection.)

The Star Glass–branded full half-pint flat liquor flask at right was the most common bottle produced at the Medford plant, and the company produced five different versions of the flask. The Star logo appears below the word "Guaranteed" surrounded with flourishes. The words "Union Made" appear at the bottom of the bottle. The glassblowers became unionized after a strike in 1899, joining the Glass Bottle Blowers Association of the United States and Canada. Below, the company's Star logo appears on an envelope with a postmark of 1893. (Right, photograph by Dennis McDonald; below, courtesy of Frank Jacobs III.)

THE STAR GLASS CO., Ltd.,

Manufacturers of

Green and Amber Bottles

and Vials,

MEDFORD, N. J.

Above, employees at the Star Glass Works pose for a group portrait in the early 1900s. According to the US Census of Manufacturers, more than 10 percent of the workforce in the glass industry comprised children under 16 in 1905, down from 30 percent in 1880. Young boys still gained employment despite child labor and compulsory education laws gaining prominence throughout the country. Below, this classified advertisement from *The Philadelphia Inquirer* dated October 1897 asks for a bright, active, 13–15-year-old snap-up boy to work in the Medford glass factory. It was not unusual for boys as young as eight years old to obtain employment in the glass industry. (Above, courtesy of the Medford Historical Society; below, courtesy of *The Philadelphia Inquirer*.)

BOY, bright and active, 13 to 15 years, to snap up in glass factory; good home. Address for two days, J., Box 175, Medford, N. J.

STAR GLASS CO WORKS 40

This William B. Cooper photograph taken from South Main Street shows the Star Glass Works Factory Building Number One containing the furnaces, at left, and the Sand Storage Building at right. Brick tunnels carried steam, water, and other utilities between buildings. (Courtesy of the Camden County Historical Society.)

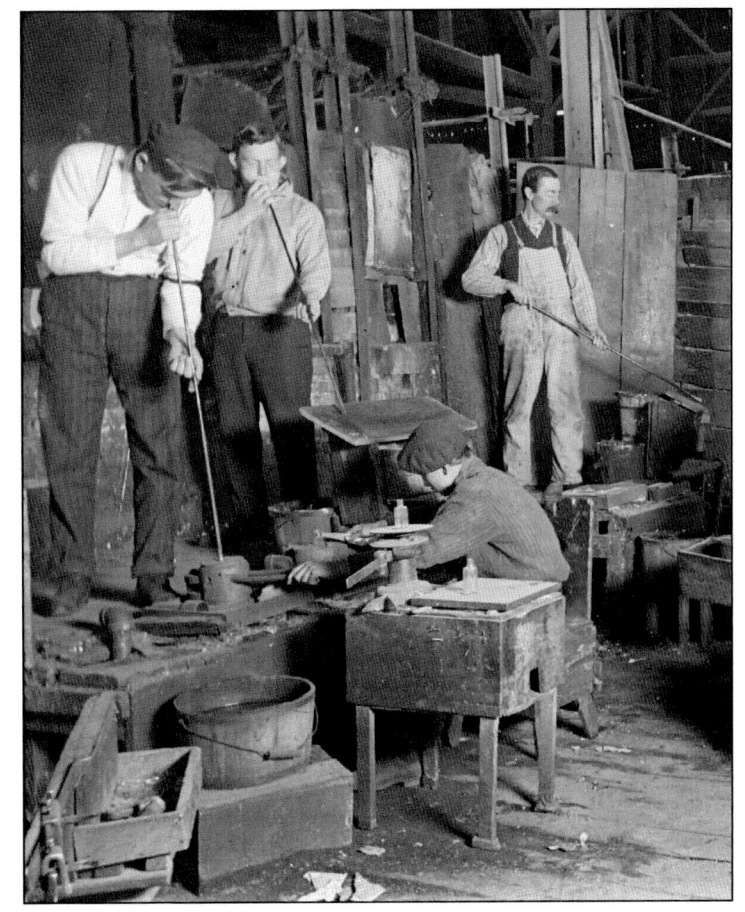

Glassblowers, known as gaffers, blew air through a blowpipe into a gather of glass within a bottle mold at the Star Glass Works during the early 1900s. A mold boy, seated, clamps the mold for the gaffer. A skilled glassblower could produce hundreds of bottles per day. (Photograph by William B. Cooper, courtesy of Dennis McDonald from the Mickle Collection.)

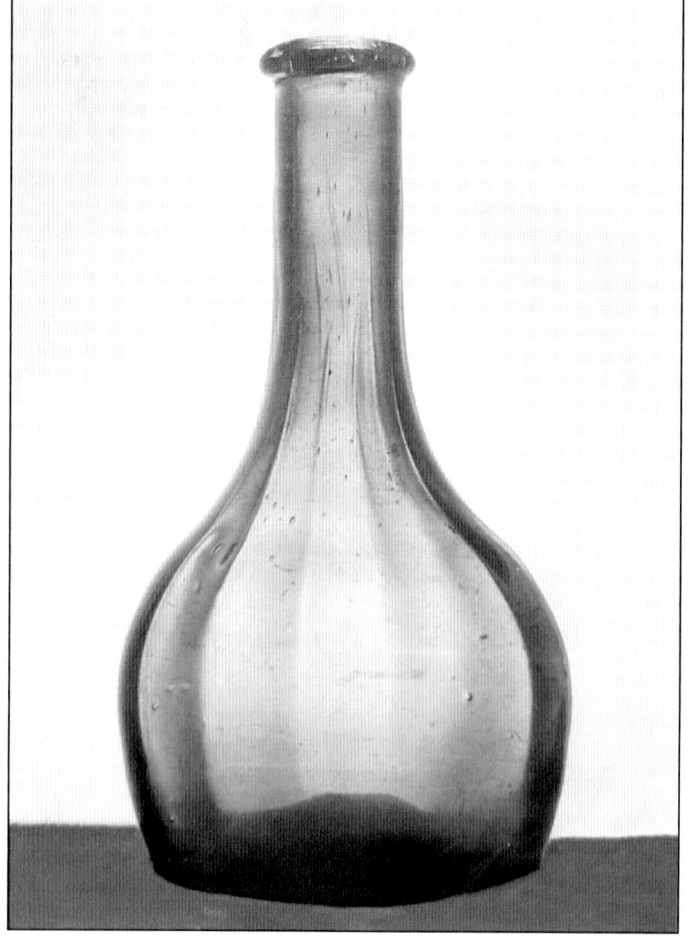

Star Glass Works employees pose for a photograph outside Factory Building Number One in the early 1900s. The company usually shut down from June to September due to the summer heat combining with the heat from the furnaces. In the late 1800s, Star Glass Works had so many orders it did not shut down for that summer. (Photograph by William B. Cooper, courtesy of the Medford Historical Society.)

The Star Glass Works plant primarily produced hollow ware, such as bottles, flasks, and other containers. An example is this squat, decanter-shaped blue bottle with its loosely defined vertical lines. The factory was known for its fast, efficient production, which allowed it to remain operational long after many other local glass factories closed. (Courtesy of the Camden County Historical Society.)

Star Glass Company was known for producing glass bottles for druggists, liquor distributors, and pickle jars. The Joseph Campbell Company started production in Camden, New Jersey, and Beefsteak Catsup was one of its main products until the company decided to produce only soup in 1914. According to Adeline Pepper writing in her book *Glass Gaffers of New Jersey and Their Creations from 1739 to the Present*, "for the Campbell Soup Company, Star Glass devised the first lock-top catsup bottles, difficult to blow as they had precision grooved necks to fit metal caps." It is not known what years these bottles were produced for the Campbell Soup Company, but the Star Glass Company experienced its best production years in 1904, 1911, and 1913, according to the *Courier-Post* of Camden, New Jersey. (Courtesy of the Campbell Soup Corporate Archives.)

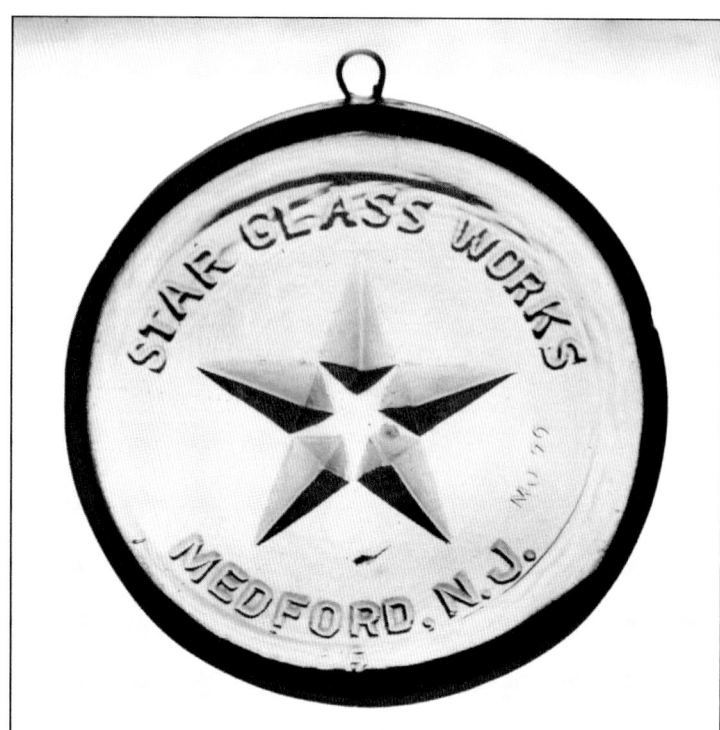

In 1979, the Clevenger Brothers Glass Works of Clayton, New Jersey, produced a souvenir four-inch-diameter clear, heavy glass disk. It included the Star company name, the trademark star pattern, the location, and an internal marking number MJ79. Caming (lead casing) surrounds the piece, and a loop at the top provides a point for hanging. The colors of these suncatchers included amethyst, blue, cobalt blue, and green. (Photograph by Dennis McDonald.)

The Star Glass Works store on South Main Street is shown at right with the factory buildings at left in this William B. Cooper photograph taken in 1905. The company was the largest employer in Medford, sometimes having more than 250 men and boys on the payroll. Quite often, the Medford Field Club baseball team would not begin its season until the glass factory closed down for the summer. (Courtesy of Dennis McDonald from the Mickle Collection.)

The Star Glass Works Company Store was within the factory complex. For the families of the workers, it provided the most convenient shopping opportunity. The Star Glass Company employees could purchase merchandise books in different denominations up to $10. The wife of the worker carried the book to the company store to purchase groceries and other supplies up to the book amount. The account book would ensure that the worker's paycheck was not used inappropriately elsewhere. Edward B. Wills managed the store while the company remained in business and continued after the company closed. The store itself closed in the 1970s. The store carried everything a household would need, serving as a combination grocery and hardware store. (Right, courtesy of Mark Scherzer; below, courtesy of Dennis McDonald.)

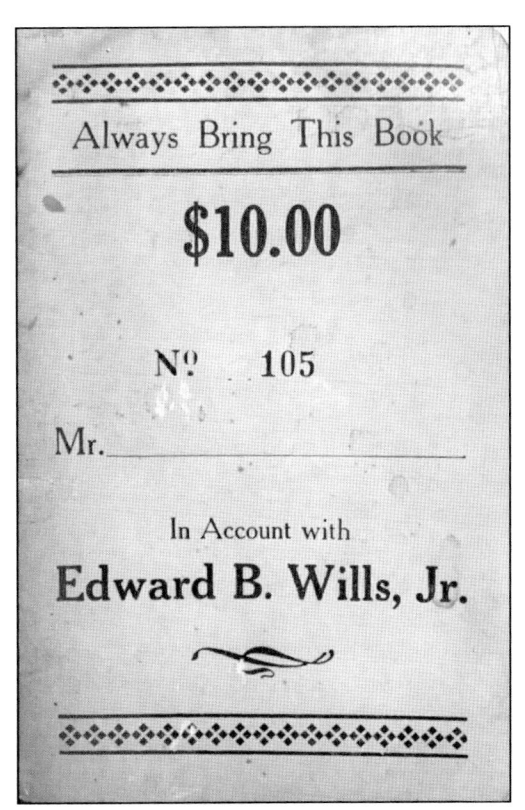

Always Bring This Book

$10.00

N⁰ 105

Mr.

In Account with

Edward B. Wills, Jr.

On May 5, 1923, the *Mount Holly Herald* reported that "the Star Glass Company expects to close its factory for the season this Saturday." Closing down for the hot summer months was normal for glass factories in New Jersey. But, a little more than two months later, an advertisement appeared in the *Glass Worker* trade journal advertising the sale of the New Jersey factory. The ad appeared on July 14, 21, and 28, 1923. No one came forward to purchase the plant, thus ending almost a century of glass production and employment for thousands of workers in Medford. (Courtesy of the *Glass Worker*.)

Four

SNAPPING TURTLE TRAPPER

Snapper soup is a local delicacy going back centuries in Medford and its surrounding towns. An article in the *New Jersey Mirror and Burlington County Advertiser* from August 1845 mentions turtle soup being served at the dedication of the Medford Glass Factory on South Main Street. Snapper soup was also a traditional Fourth of July meal throughout Burlington County. The *Mount Holly News* mentions that during a double-header baseball game on July 4, 1906, at the Medford Field Club, there would "be a band, bowling, fireworks, and lots of the snapper soup that has made Medford's holiday fetes famous."

Medford resident Herbert "Smokey" Misner (1919–1987) trapped snapping turtles for most of his life. He learned the skill from "Pineys" (people that live in the Pine Barrens) when he was 14. Together, they walked in drained bogs and poked deep in the mud with long poles. When they hit something hard with the stick, they would stand on it to see which way the turtle moved. As the turtle moved forward, they would reach down through the mud, sometimes up to their shoulders, grab the snapper by the tail with their hands, and place the turtle in a canvas bag.

Misner was an auto mechanic by trade but spent his off hours trapping. He was one of the last of the Medford turtle trappers. He asked local farmers and camp directors if he could trap the snapping turtles in the cedar water ponds on their property. Later he would fashion his own traps out of wire mesh and hand-knit funnels and place the cylindrical device into ponds with a can of oily sardines as bait.

The next day Misner would collect the traps by rowboat or by walking through rough brush to the edge of the ponds. When he accumulated about 500 pounds of turtles in his backyard bathtubs, he would place them in the back of his pickup truck and deliver the live turtles to local restaurants, including Bookbinder's in Philadelphia, Pennsylvania, as the main ingredient for snapper soup.

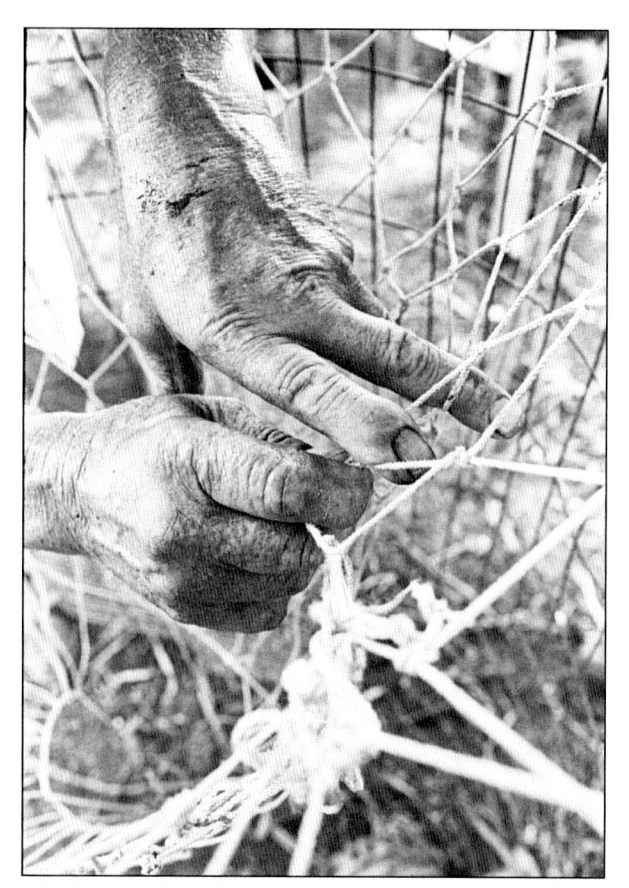

The gnarled hands of Herb Misner weave a new net in the kitchen of his house in the Chairville section of Medford. He knots and knits cotton cord and secures it to the entrance of a cylindrical wire snapping turtle trap of his own design. He learned how to make the nets from a book. The hand-knit woven funnel will not allow the turtle to escape once it enters the trap. The sharp beak and claws of the turtle, attempting to escape from the trap, often damage the netting, leading to continuously repairing the funnel. (Both photographs by Dennis McDonald, courtesy of the American Folklife Center/Library of Congress AFC 1991/023: 235200-04 and AFC 1991/023: 235200-09.)

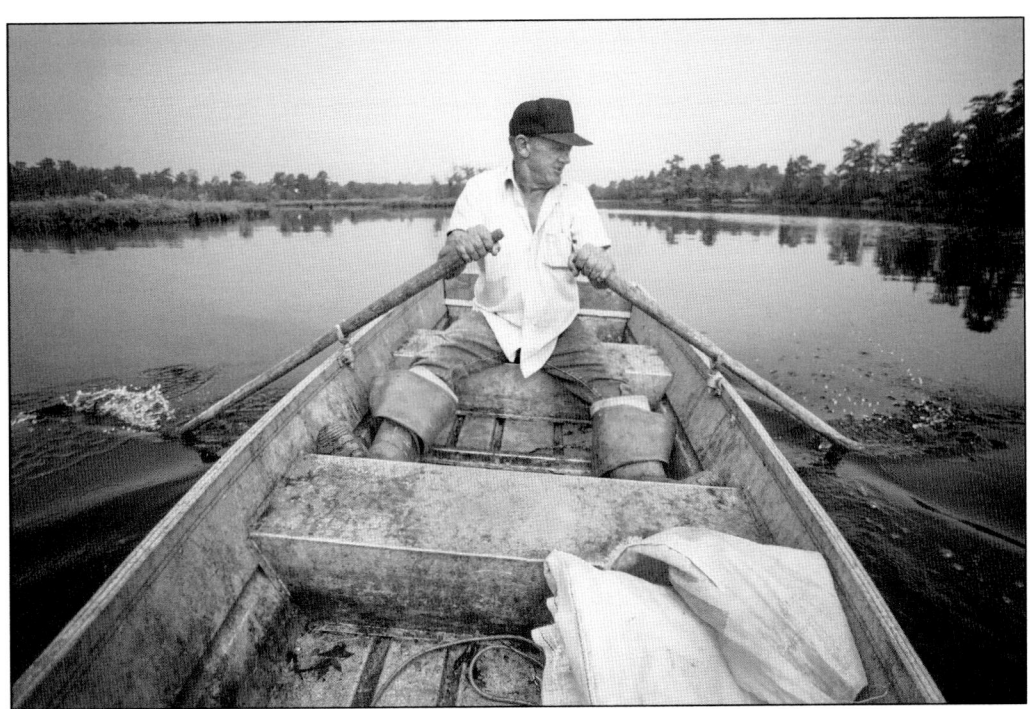

Sixty-six-year-old Herb Misner rows a battered Sears and Roebuck aluminum boat across a lake to where he placed his snapping turtle trap. He used cans of oily sardines as bait to attract the turtles and follows the oily path to the trap. The most dangerous part of catching a snapper, with its sharp beak and claws, is grabbing it by the tail and placing the caught turtle inside the canvas bag. It is even more difficult while standing up in a small metal rowboat. (Both photographs by Dennis McDonald, courtesy of the American Folklife Center/Library of Congress AFC 1991/203: 235200-12 and AFC 1991/203: 235200-17.)

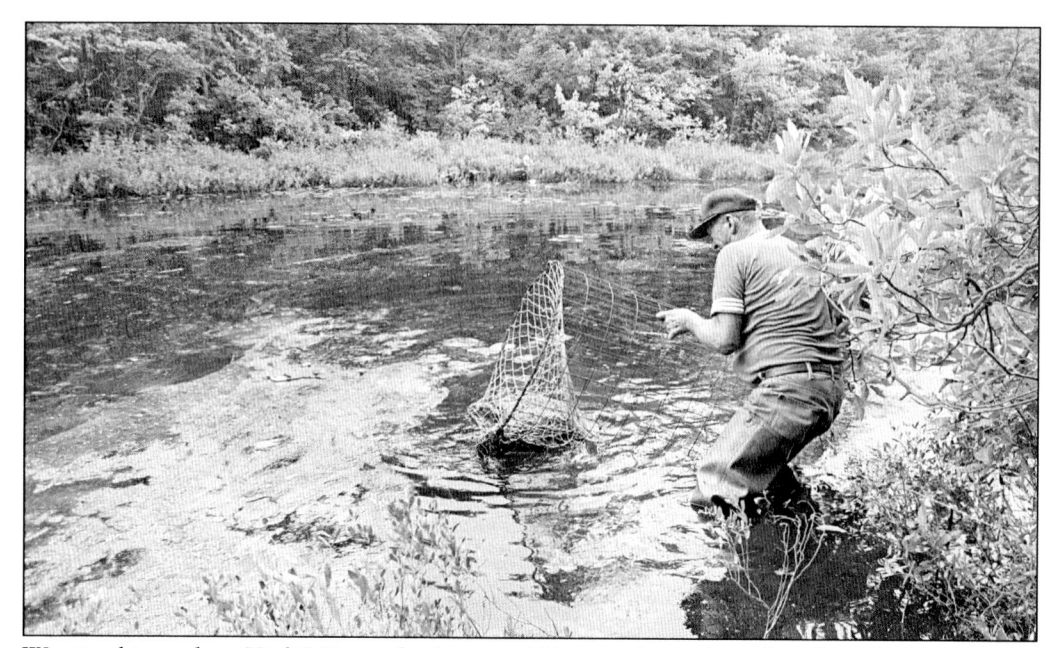

Wearing hip waders, Herb Misner checks one of his traps located on the edge of a Pine Barrens pond on the property of Lake Ockanickon in Medford. If there is a turtle inside, he pulls the trap out of the muddy cedar water toward the shore. Misner checks the size of the snapper before hauling the trap back to his truck. According to New Jersey Department of Environmental Protection regulations, a snapping turtle's shell must be at least 12 inches to be harvested. (Both photographs by Dennis McDonald, courtesy of the American Folklife Center/Library of Congress ACF 1991/203: 235200-07 and AFC 1991/203: CDM-023.)

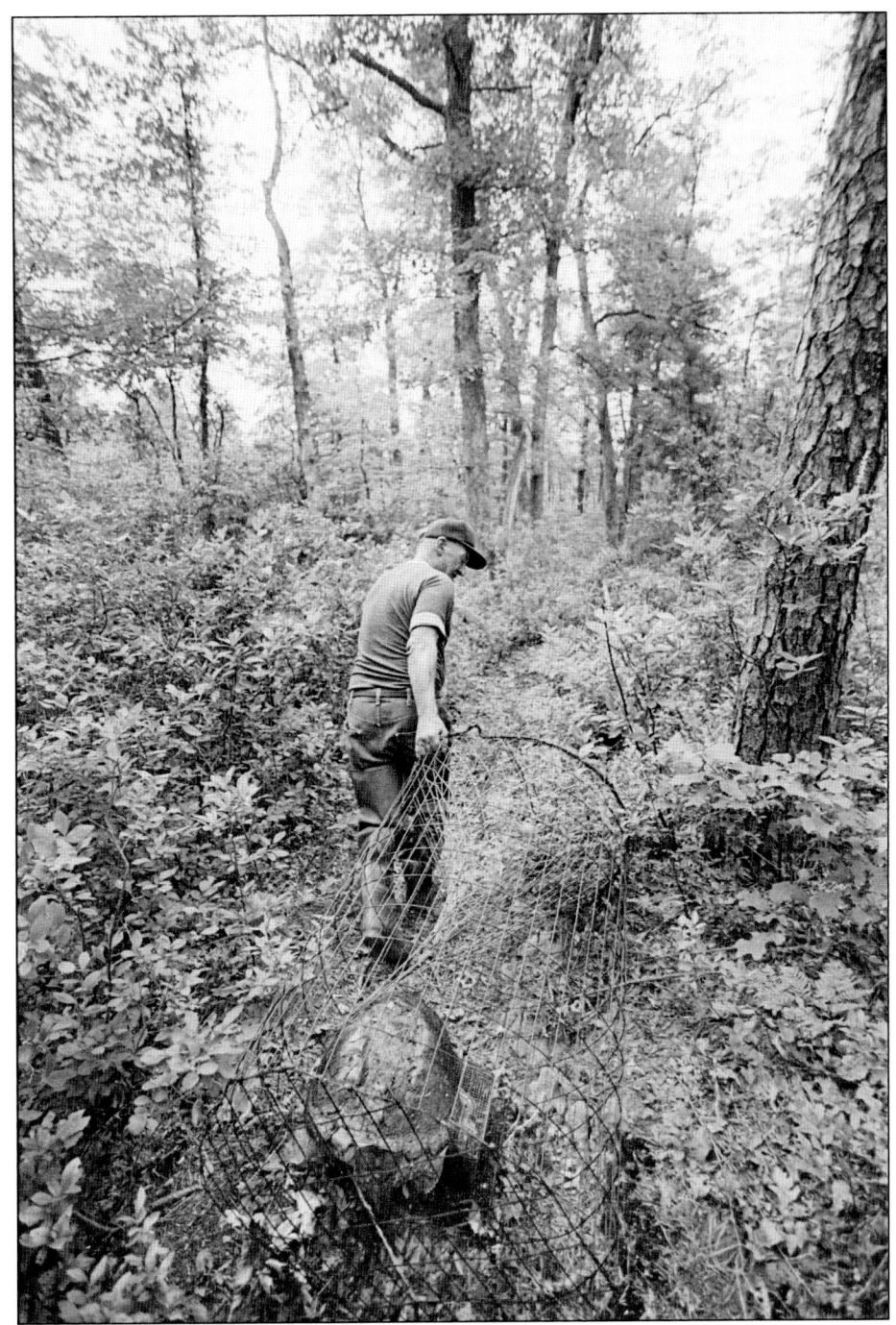

Herb Misner drags the trap, with the snapping turtle inside, back to his truck through the heavy brush. The half-mile journey is difficult with a 20-pound turtle inside the trap. He captures the turtles wherever the owners let him, from youth camps, private ponds, marshes, and slow-moving streams in Medford and throughout Southern New Jersey. He says trapping is a good way to get exercise. (Photograph by Dennis McDonald, courtesy of the American Folklife Center/Library of Congress AFC 1991/203: 235200-08.)

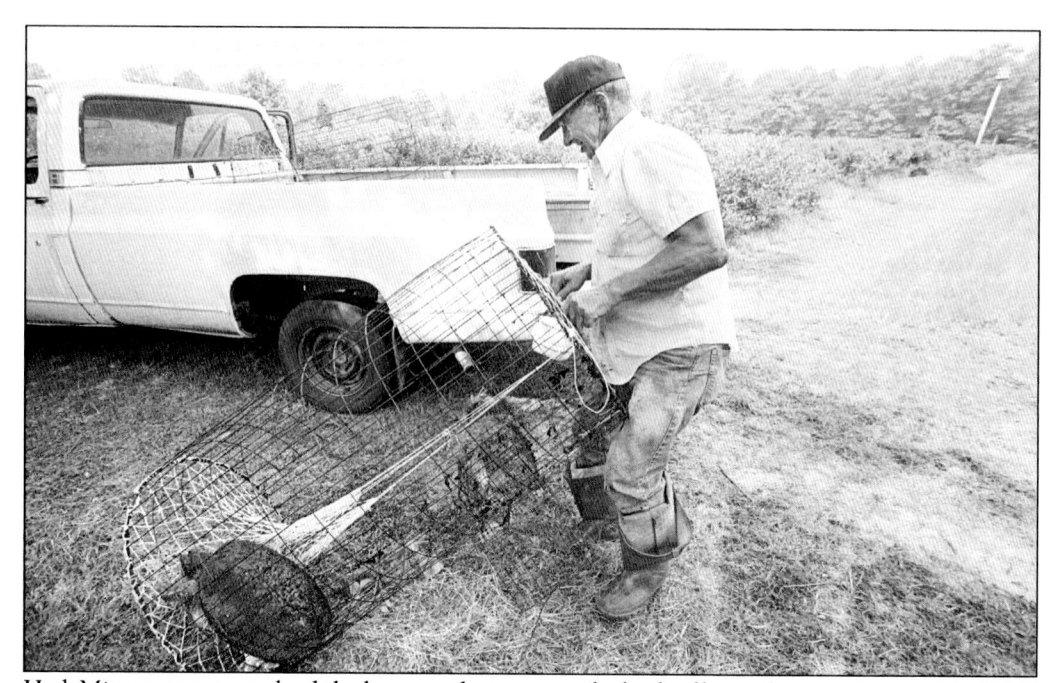

Herb Misner prepares to load the homemade trap onto the back of his pickup truck near a blueberry field. Other traps that he has collected during his rounds sit in the back of his truck. New Jersey state law mandates that traps must be checked no less than every 24 hours. The common snapping turtle (*Chelydra serpentina*), a native of North America, has survived for millions of years and has no known predators. Below, Misner unloads his trap at a local breakfast establishment. (Both photograph by Dennis McDonald, courtesy of the American Folklife Center/Library of Congress AFC 1991/203: 235200-13 and AFC 1991/203: 235200-04.)

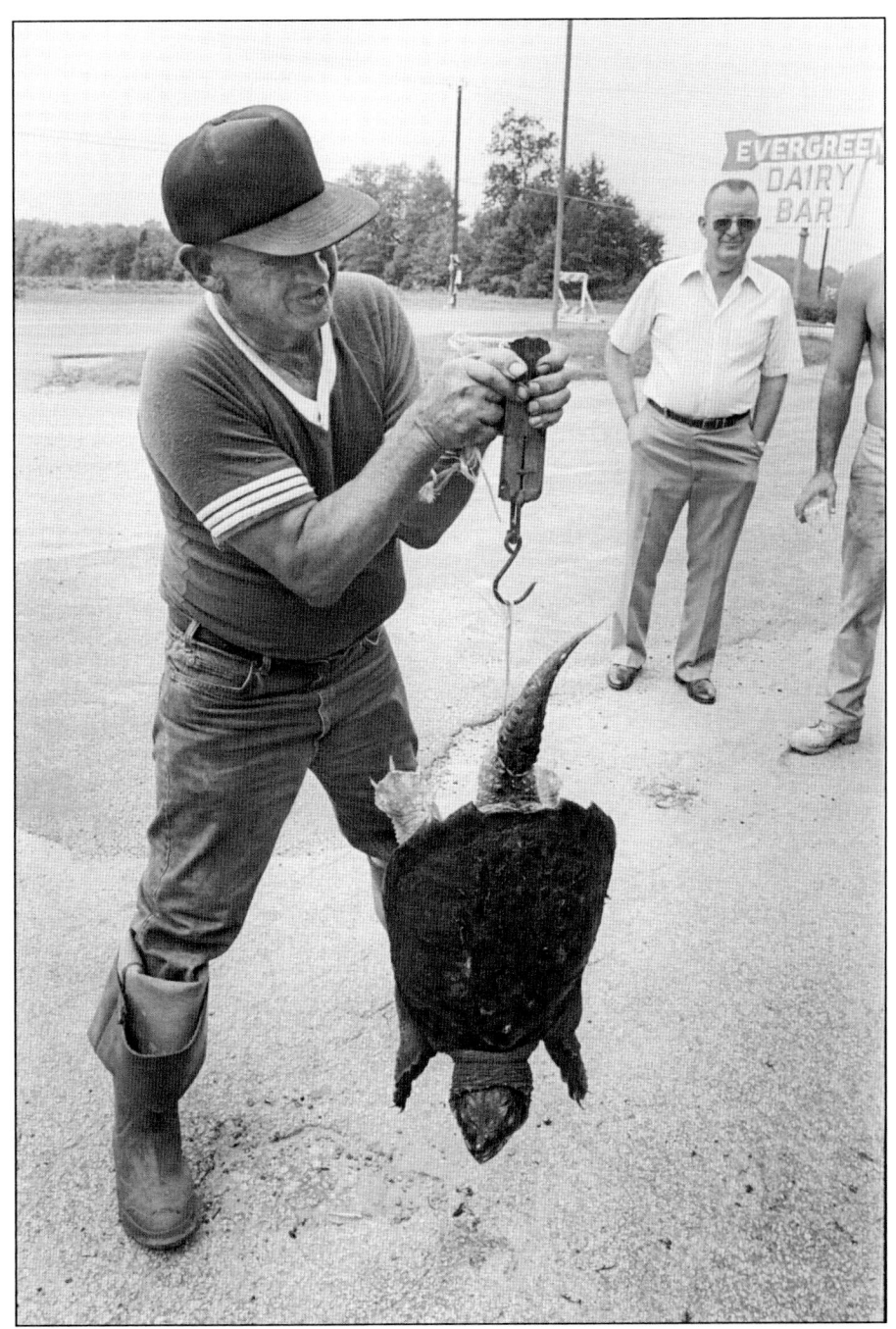

Turtle trapper Herb Misner weighs a snapping turtle in the parking lot of the Evergreen Dairy Bar in front of interested observers. This turtle weighed in at less than 20 pounds and was about seven years old. The approximate age of a turtle can be determined by the scales that cover the turtle's shell. Snapper soup had its heyday back in the 1950s, when even the Campbell Soup Company marketed its version. Misner's wife, Thelma, made her snapper soup with potatoes, onions, and hard-boiled eggs. (Photograph by Dennis McDonald, courtesy of the American Folklife Center/ Library of Congress AFC 1991/023: 235200-05.)

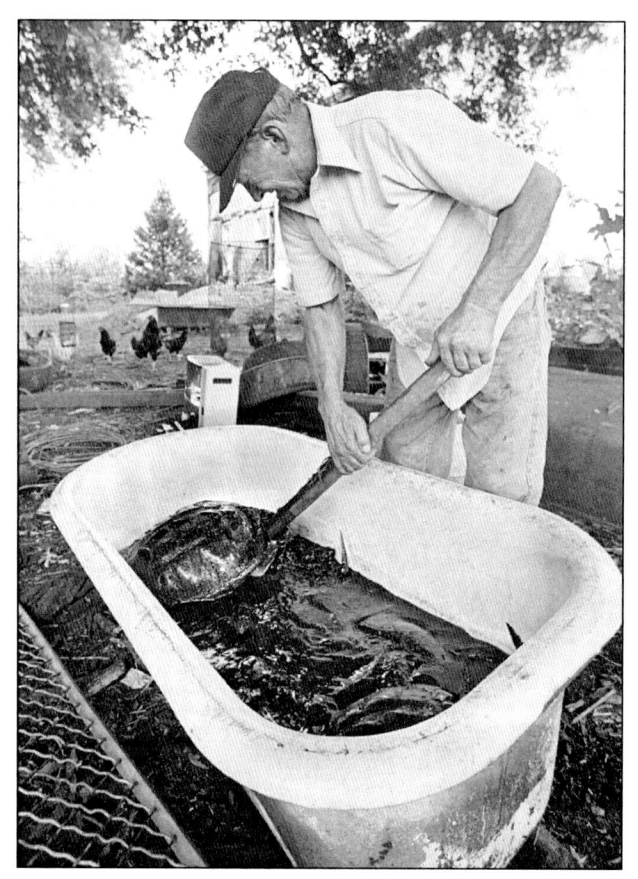

Herb Misner uses a shovel to remove a snapping turtle from a claw-foot bathtub in his backyard. The average size of a snapper is about 10 pounds, but Misner caught a few that weighed over 40 pounds. Some years Misner caught as many as 300 turtles during trapping season, which runs from April 1 to October 31. For a few weeks, they are in the bathtub before they are brought to the markets in New Jersey and Philadelphia to be made into snapper soup. (Both photographs by Dennis McDonald, courtesy of the American Folklife Center/Library of Congress AFC 1991/203: 235200-15 and AFC 1991/203: 235200-18.)

Five

CRANBERRY FARMING

Cranberries are native to Southern New Jersey's Pine Barrens wetlands. The indigenous Lenni Lenape used the fruit for a variety of purposes, including seasoning food, medicinally, and as a dye. In the late 1800s, ship captains ordered barrels of cranberries, a robust source of Vitamin C, to prevent scurvy among sailors.

From 1870 forward, Medford cranberry farming experienced a significant boom. Everyone sought to take part in the newest "road to riches." Prominent citizens, such as Braddock, Garwood, Bowker, Haines, Wilkins, Thorn, Reeves, Christopher, and Hinchman, all caught "cranberry fever." Numerous abandoned ironworks and mills provided easy conversion of millponds into cranberry bogs. By 1883, the New Jersey Cranberry Association reported that Medford boasted 18 cranberry farms spanning 525 acres, positioning Medford as the fifth highest-producing cranberry district in the state. Twenty years later, an article in Camden's *Morning Post* from October 14, 1903, reported that Medford served as "one of the principal cranberry centers of the county." Considering Burlington County contained more than 4,500 acres of cranberry bogs in 1909, Medford's significance as a cranberry cultivator becomes clear.

Medford's cranberry production adapted to meet changing times. Harvesting methods progressed from hand picking to the wooden scoop. Later, mechanized walk-behind harvesters were used. Finally, wet harvesting made the process quicker and more economical. Medford farmers originated two cranberry plant varieties, or cultivars, the Braddock Bell and the Garwood Bell, the latter first planted by Israel Garwood in 1875.

As the value of the land in Medford increased for redevelopment, cranberry farming dwindled. Today, only one cranberry farm remains. Tom Gerber, a fourth-generation cranberry farmer, runs Quoexin Cranberry Company, a thousand-acre operation with 60 acres of cranberry bogs, including the oldest bogs in the state. A dedicated steward of his land, Gerber values his farm's historic significance. More than 150 years ago, William Braddock first cultivated on Gerber's property. Over the years, different growers including the Evans, Wills, Sharpless, and Knight families farmed here.

The future of the Quoexin bogs is protected; the New Jersey Farmland Preservation Program purchased the development rights to the property.

Various recipe booklets were used to promote cranberries in the early 1900s. This booklet was produced by the New Jersey Cranberry Sales Company of Medford, New Jersey. The recipes included within the booklet helped growers market their fruit to consumers. Aiding digestion and clearing the complexion were ways to introduce cranberries to the female shopper. The company predated the American Cranberry Exchange, which formed in 1911. (Courtesy of Dennis McDonald.)

This 1916 agricultural map of New Jersey shows the area of Burlington County, below Medford, where cranberries were grown. Not much else could be grown in the sandy soil of the pinelands. The map also shows two railroad lines coming into Medford. The railroads brought in Italian pickers from Philadelphia to harvest the fruit, and the berries were shipped out by rail to markets across the country. (Map prepared by Franklin Dye, courtesy of the New Jersey Department of Agriculture.)

Originally, local people called Pineys, residents of the Pine Barrens, picked the cranberries by hand. As the production and the number of farms increased, Italian workers from South Philadelphia with their wives, children, and baggage traveled by train during the harvest to the cranberry bogs of Southern New Jersey, including Medford. The original Italian workers' house, below, still remains on the property of the Quoexin Cranberry Company. (Left, courtesy of the Mickle Collection; below, photograph by Dennis McDonald.)

A collection of cranberry scoops and peck boxes is arranged inside the Quoexin Cranberry Company packinghouse. Scoops were introduced in 1887 as a quicker way to harvest cranberries than handpicking. Working with the scoop required both strong arms and a strong back. (Photograph by Dennis McDonald.)

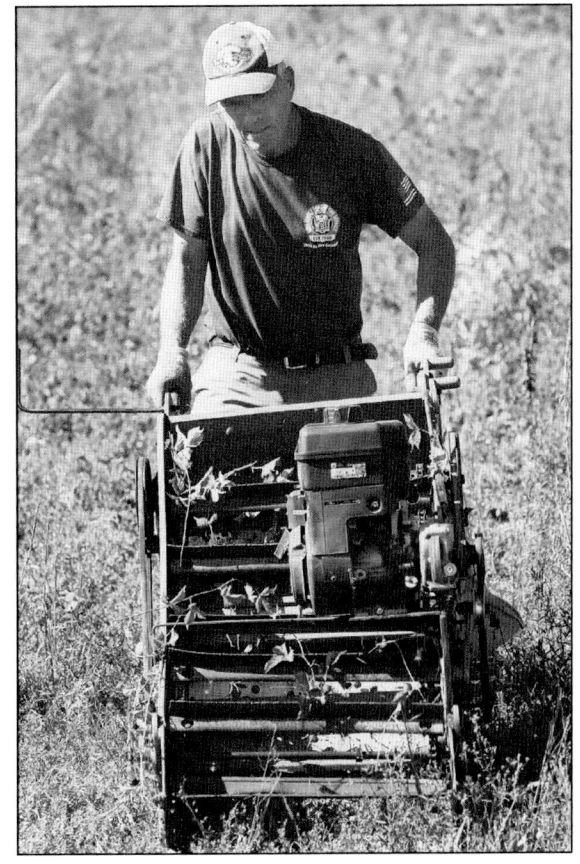

Tom Gerber, the co-owner with his former wife, Christine, of the Quoexin Cranberry Company, uses a self-propelled Western Picker to harvest the Stevens variety of cranberries in the Ambriel Bog on his farm. All the bogs on his farm have names. This one is named after his daughter, Ambriel, because it was replanted in 1998, shortly after she was born. (Photograph by Dennis McDonald.)

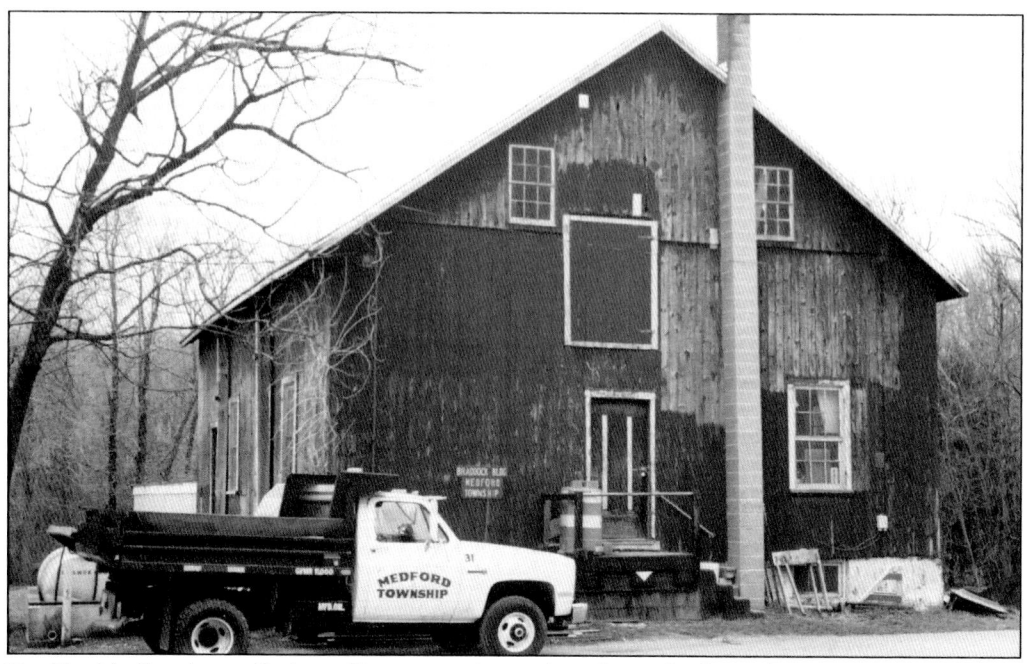

Braddock's Cranberry Packing House was located at the end of South Street. Braddock had numerous cranberry packinghouses throughout Medford. After its life as a packinghouse, Medford Township used the shed as its maintenance department for storage until the early 2000s, when it was torn down. At one time, Medford had a dozen or more cranberry packinghouses; today, only a few remain. (Courtesy of Lois Ann Kirby.)

A Braddock cranberry packing label was attached to the ends of crates of cranberries in the packinghouse for shipment. The crate size was a half-barrel, and a barrel of cranberries usually weighed 100 pounds. The Braddock family was one of the largest cranberry growers in the area. (Courtesy of Philip Brown.)

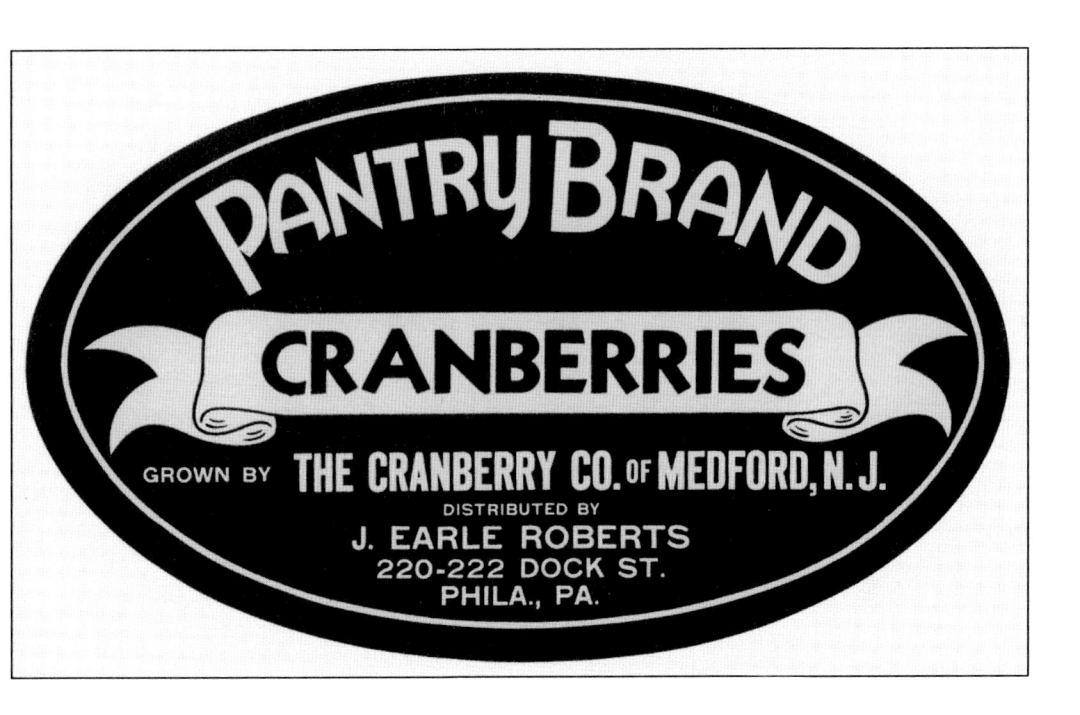

In 1911, the Grower's Cranberry Company of New Jersey established cranberry labels or brand names to differentiate color, size, and condition for its members. The Brick family, independent cranberry growers in Medford, established the "Pantry Brand" at about the same time. The Brick cranberry packinghouse was located on Charles Street in the village of Medford and still exists today as one of the few remaining packinghouses. (Above, courtesy of Dennis McDonald; below, photograph by Dennis McDonald.)

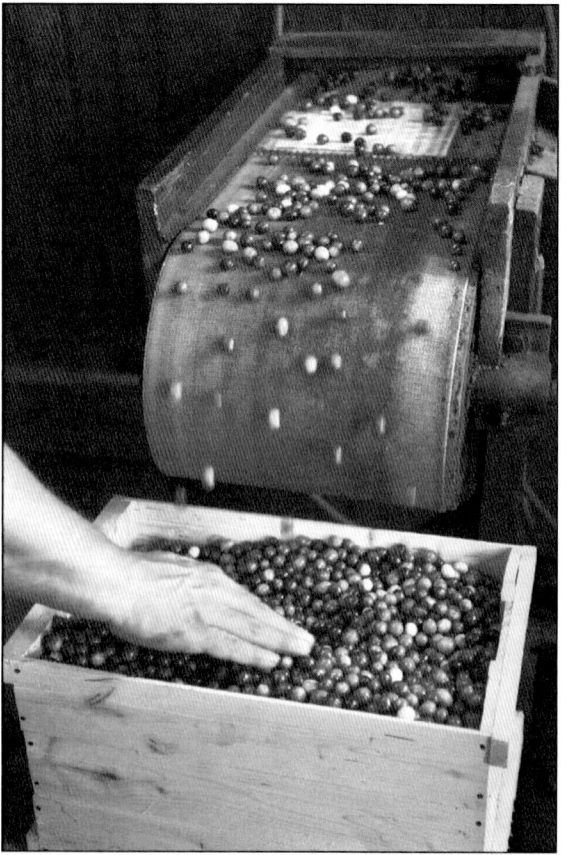

Above, Robert Brick, a fourth-generation cranberry farmer, operates a century-old Hayden Separator in his family's Medford Village packinghouse. The machine's iron wheels and belts separates the cranberries by the bounce method, where the good, firm berries bounce to the front and the soft berries fall to the bottom. At left, Robert levels the berries in the one-quarter barrel box as they come off the belt in the sorting room. (Both photographs by Dennis McDonald, courtesy of the *Burlington County Times*.)

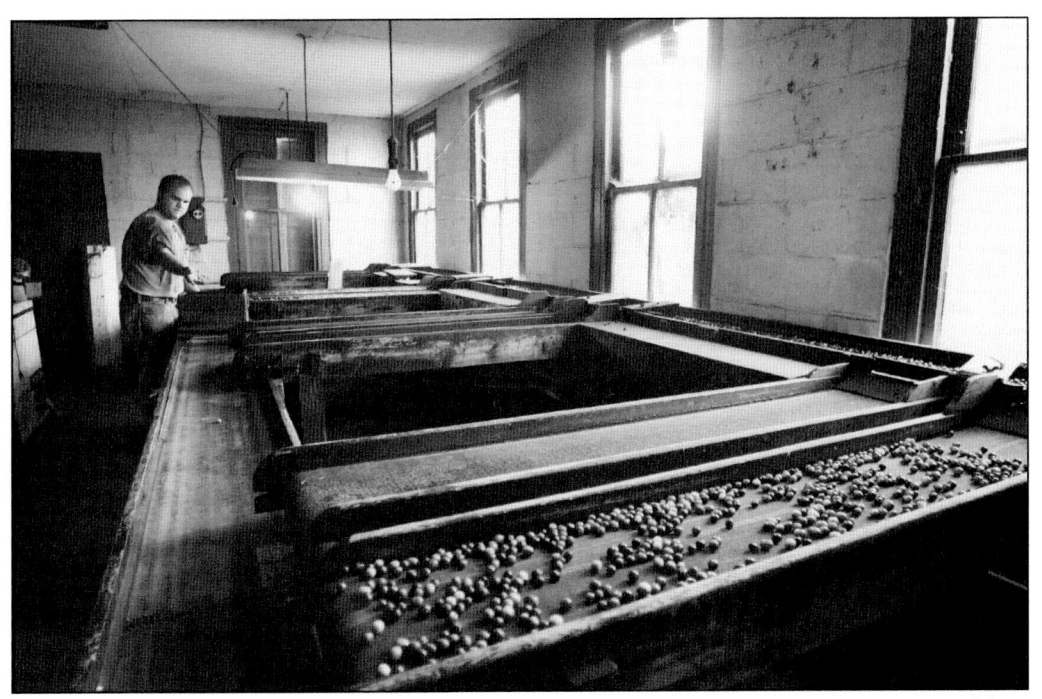

Above, Benjamin Brick, a fifth-generation cranberry farmer, places cranberries on a sorting table at the family packinghouse on Charles Street. The sorting table once held eight seated people sorting berries along the belts. The 100-year-old building housed the machinery from the early 1900s. The Brick family, who once farmed more than 1,100 acres in the southern section of Medford, no longer grows cranberries. Below, fresh dry harvested cranberries await shipment to local businesses and bakeries. (Both photographs by Dennis McDonald, courtesy of the *Burlington County Times*.)

Above, ripe Stevens variety cranberries hang on the vine in the Ambriel Bog at the Quoexin Cranberry Company farm. This variety of cranberry was first tested at Whitesbog, Pemberton Township, New Jersey, and introduced in 1950, according to Paul Eck in *The American Cranberry*. Below, Benjamin Brick uses a box sieve to remove the vines from the berries. In the background, William Achey uses a self-propelled Western Harvester to pick the berries off the vines using the dry harvesting method. (Both photographs by Dennis McDonald.)

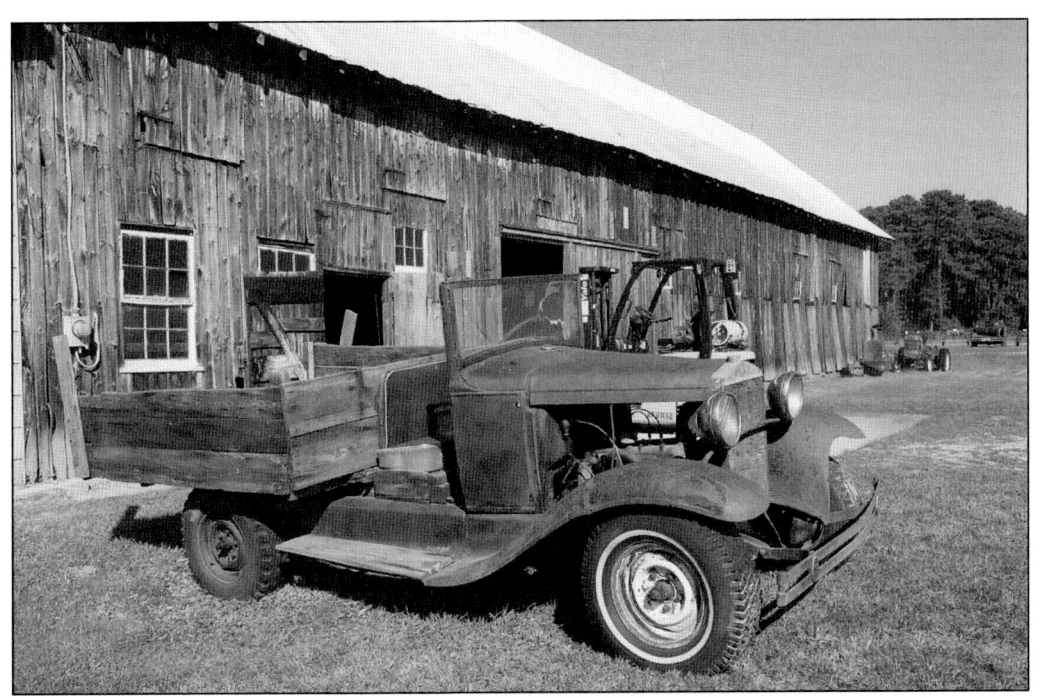

The Quoexin Cranberry Company packinghouse, above, sits in a field surrounded by bogs. William S. Braddock and Samuel Williams had the packinghouse built in 1860. A 1929 Ford Model A open-cab work truck sits in front, which was used until just a few years ago. Inside the building, workers unload boxes of fruit weighing approximately 33 pounds each. Quoexin sells its cranberries to local wineries, large and small grocery stores, and bakeries. (Both photographs by Dennis McDonald).

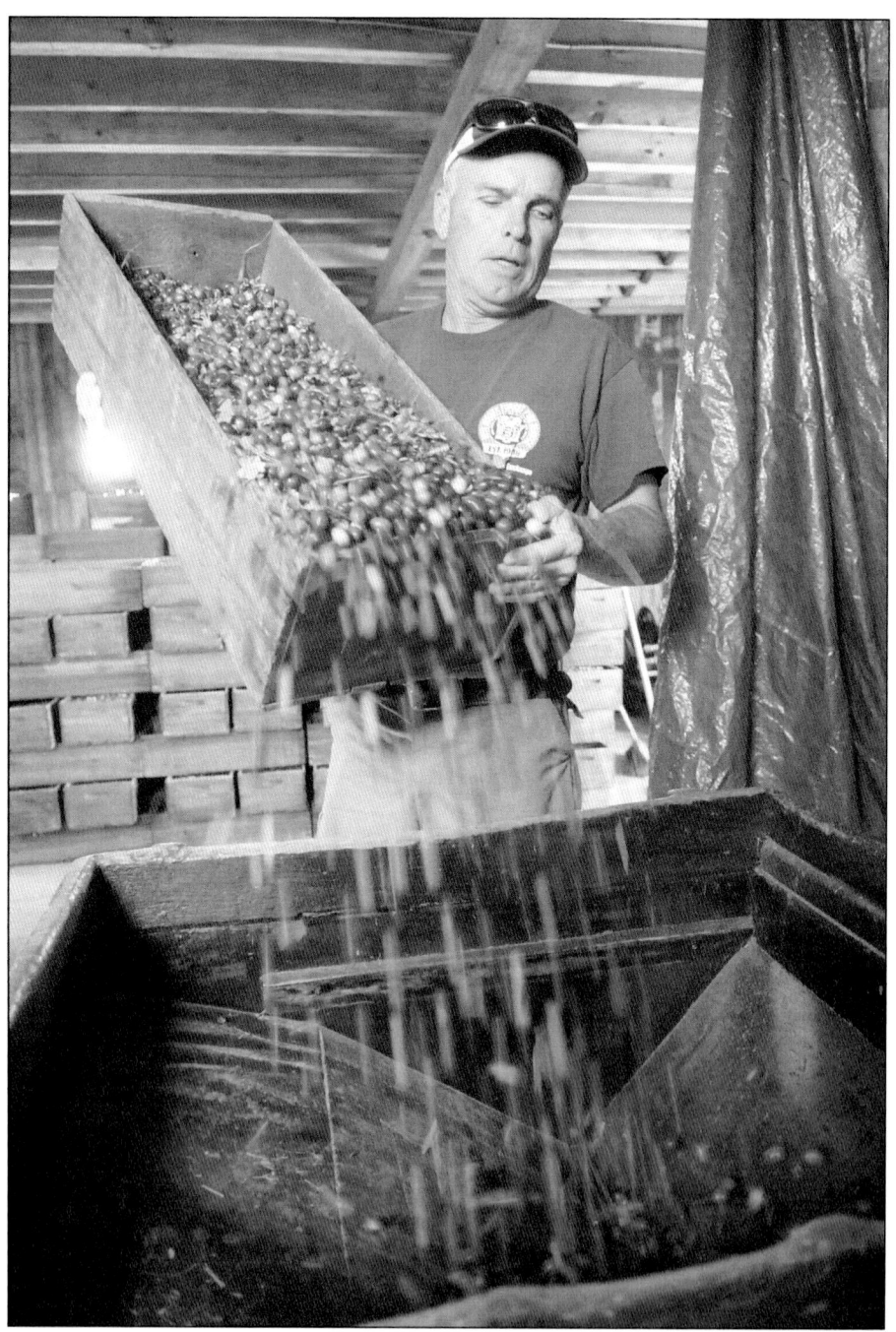

Tom Gerber, the co-owner of the Quoexin Cranberry Company, pours Stevens variety cranberries into a Hayden Separator, which sorts the berries for shipment. The Hayden Separator can sort 100 barrels of cranberries a day. This 1892 machine originally came from the cranberry packinghouse at Atsion, New Jersey. When Joseph Wharton purchased the Atsion property in 1892, he cultivated cranberries on the site and used the buildings on the property for sorting and packing. Small cranberry operations, like Quoexin, still use equipment that many people consider antiques. (Photograph by Dennis McDonald.)

Six

CAMP OCKANICKON AND CAMP MATOLLIONEQUAY

During the early 1900s, the area Young Men's Christian Association (YMCA) opened Camp Ockanickon, named for a Lenape *sakima* (leader). The YMCA initially leased various locations in New Jersey and Pennsylvania, including 12 years at New Egypt's Brindle Lake. The YMCA finally purchased its present camp location in Medford in 1926.

Camp Ockanickon's arboreous land had historically served the iron and timber industries. Charles Read's short-lived 18th-century Aetna Furnace and later Jabez Buzby's sawmill both exploited the area's natural resources before the lake transitioned to being a cranberry bog.

In late April 1926, Henry Stockwell, secretary of the Burlington County YMCA, purchased more than 400 acres from Thomas H. Strain, including Upper Aetna Lake. The YMCA rapidly transformed the site into a camp for the upcoming summer. The former cranberry packinghouse became the camp administration building, and a new dining hall accommodating 200 campers was built. Events then moved swiftly: moving day was June 12, opening day was June 24, and the official dedication occurred on June 27 with 1,800 people attending.

Children that attended the wilderness camp typically arrived by automobile. Campers could also arrive at the Atsion Station, the official camp train station, on the Central Railroad of New Jersey and then be transported to Camp Ockanickon.

During its first season, Camp Ockanickon held four one-week overnight sessions for boys between the ages of 12 and 16. The next year saw camp life extended for six weeks, including a four-week girls camp in August. In 1932, Camp Ockanickon opened the segregated Upper Lake Camp for Black boys with an all-Black staff. Three years later, the camp hosted children from the Four Mile Colony, located in nearby Woodland Township. The girls' camp, Camp Matollionequay, named after Ockanickon's wife, opened in 1937.

In 1990, Lake Stockwell Day Camp opened. Today, the YMCA of the Pines holds a nine-week camping season. The now expanded 800-acre property provides boating, water safety, swimming, hiking, horseback riding, woodworking, archery, talent shows, nature education, and challenge course activities.

On lands that were once part of the "Iron Master" Charles Read's empire, Henry F. Stockwell, Esq., secretary of the Burlington County YMCA, purchased the former Jabez Buzby sawmill property in 1926. The permanent home of Camp Ockanickon included 550 acres of wilderness with two lakes, a "mountain," and a few buildings in the southeast part of Medford Township. The property was last used as a cranberry farm, and once the sale was complete, the cranberry packinghouse was quickly transformed into the camp administration building. (Both, courtesy of the YMCA of the Pines.)

The year 1926 was busy for Camp Ockanickon. The new camp's land in Medford was purchased in April of that year. The administration building was converted from a cranberry packinghouse. The mess hall was built, and a fresh source of water was located. Moving day from the former camp in New Egypt was June 12. Two hundred new campers arrived in Medford, above, on June 24 for the first week of camp. And June 27 saw the official dedication of the permanent site of Camp Ockanickon, known as "Acres for Character," with over 1,800 people in attendance. (Above, courtesy of the YMCA of the Pines; below, courtesy of the Medford Historical Society.)

Young girls were allowed to attend Camp Ockanickon for the first time in 1927. The camp opened on August 5, after the boys' camping session was finished. It ran for four weeks and included basketry, first aid, swimming, boating, music, soap carving, and nature study. (Courtesy of the YMCA of the Pines.)

Up until 1929, the entrance to Camp Ockanickon was indicated by a Colonial-style sign made by one of the woodworking classes at summer camp. In the spring of that year, volunteers built a rustic arch across the entrance and landscaped either side of the road with evergreens and mountain laurel. (Courtesy of the YMCA of the Pines.)

A new building was erected at Camp Ockanickon after the property was purchased in April 1926. According to the *Daily Record* of Long Branch, New Jersey, on June 3, 1926, "on a little rise of ground at the head of, and overlooking the lake, a modern and well-equipped dining hall is in the process of erection." There was a problem though with the dishwashing system. With 200 boys and three trips to and from the dining hall and the dishwashing apparatus, according to the *Daily Record*, "during the last week of camp, 1926, several engineers were brought in who made time studies of the whole operation of getting a boy and his dishes from the table and back again." Double doors and double lines were suggested as part of the answer. (Both, courtesy of the YMCA of the Pines.)

According to the September 14, 1928, *Freehold Transcript*, "the music at Camp Ockanickon was one of the best features of the camp program." Wilmer A. Robbins was in charge of the orchestra and music at the camp in the early years at Medford. "Songs are an essential part of camp," according to Judy Sailer in the YMCA Camp Ockanickon 100th anniversary booklet. (Courtesy of the YMCA of the Pines.)

Building model sailboats in the workshop at Camp Ockanickon is a favorite activity. E.R. Bally of Merchantville, New Jersey, donated 100 hulls to the campers in 1928 for the boys to sand and shave the sailboats into shape. Once they add the jibs, combination keel/centerboard, and mainsails, they were ready to be entered in competition on the lake. (Courtesy of the YMCA of the Pines.)

Swimming, lifesaving instruction, rowing, and canoeing are a substantial part of the Camp Ockanickon experience. Lifeguard training took place prior to the start of camp with the American Red Cross issuing certificates. Swimming was part of the campers' daily activity. Plus, many campers went swimming during their free periods. In order to use a watercraft, campers had to pass their swimming test. The lakes at the camps were mostly shallow. When a diving tower was erected 50 yards out from the beach, a hole was blasted by representatives from the DuPont Company to provide enough depth. (Both, courtesy of the YMCA of the Pines.)

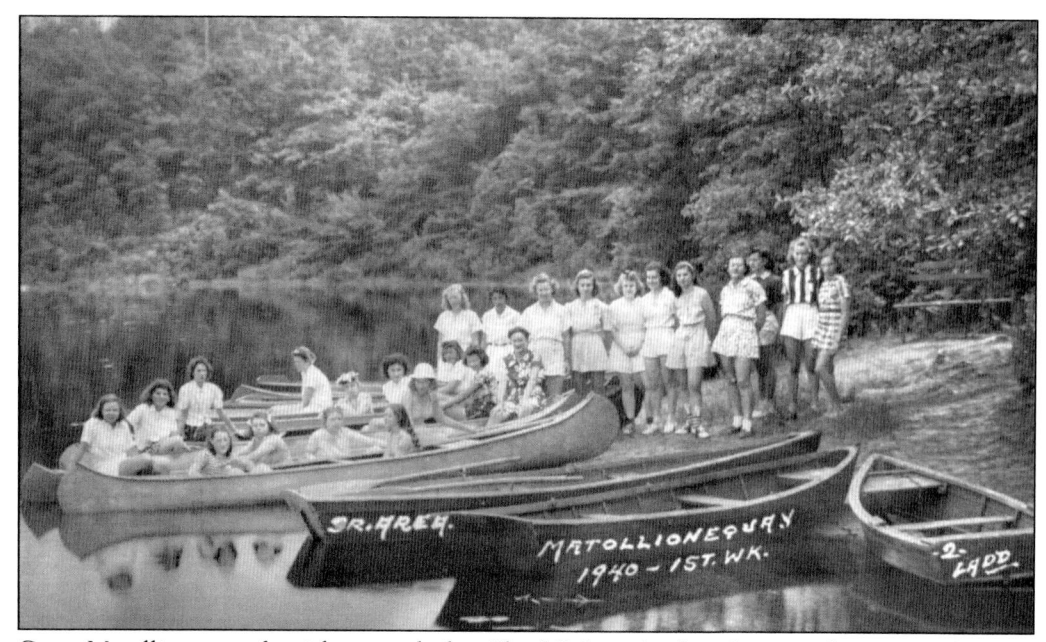

Camp Matollionequay for girls, named after Chief Ockanickon's wife, opened in 1937. Although girls had been camping at Camp Ockanickon, above, since the camp moved to Medford in 1926, their shortened session was held after the boys' camp ended. Matollionequay had its own dining hall, administration building, and swimming beach. The girls' and boys' sessions were now each six weeks. Campers were divided into age groups, and some tent houses were separated away from the main groups with six or seven girls and one or two counselors. The photograph below shows the girls at Camp Matollionequay. (Both, courtesy of the YMCA of the Pines; below, photograph by Ladd Studios.)

Campers and counselors gather for a group photograph at the bridge to the swimming area at Camp Matollionequay in 1938. This was the second year for the girls' camp, and the six-week camp ran simultaneously with Camp Ockanickon, the boys' camp. Girl campers came from Burlington, Camden, Gloucester, Monmouth, Cumberland, and Atlantic Counties and from states up and down the East Coast. Hazel Metcalf, a member of the Burlington High School faculty, directed the camp that year, taking over from Evelyn Smith. (Photograph by Ladd Studios; courtesy of the YMCA of the Pines.)

Camp Matollionequay for girls opened in 1937 and could accommodate 200 campers per week during the six-week season. Each cabin would hold seven campers and a counselor. Thirty-five women and girls attending college acted as counselors during the first year. The girls took part in different activities including horseback riding, swimming instruction and a swim meet with girls from Medford Lakes, lectures on nature, drama classes, hiking, and boating. Quite often there were competitions between different tent areas. (Both, courtesy of the YMCA of the Pines.)

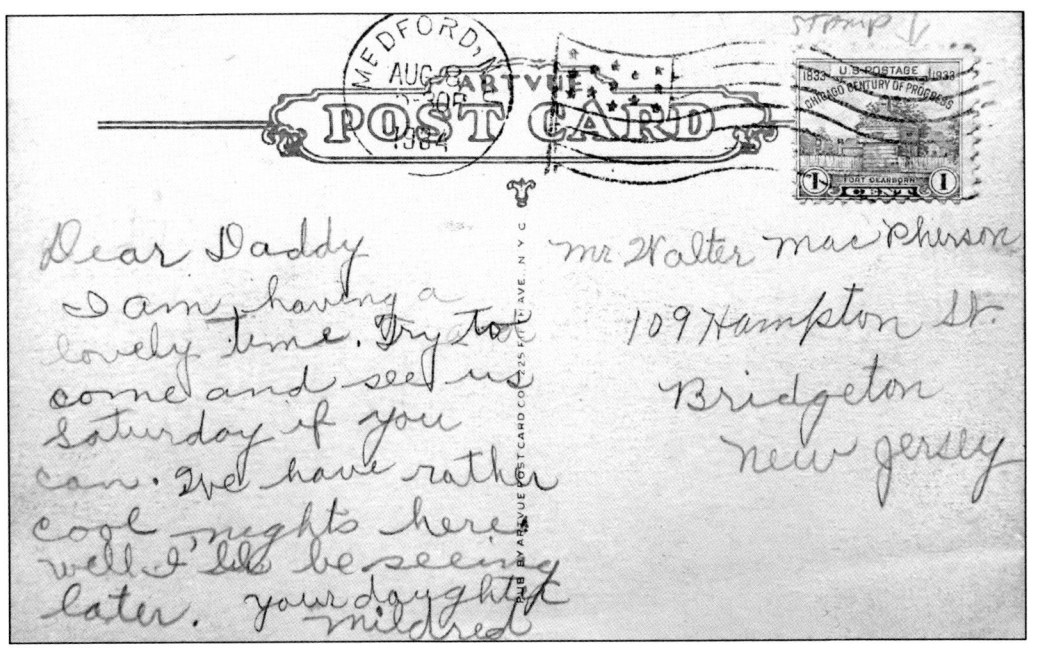

Letters home are one of the constants at any camp. This postcard, written by camper Mildred MacPherson to her father in 1934, is one example. Of course, the most famous letter from camp was written and sung by Allan Sherman in 1963, "Hello Mudder, Hello Faddah." (Courtesy of Dennis McDonald.)

Over the years, numerous groups used Camp Ockanickon prior to the opening of the YMCA camp season. In June 1936, the 4-H Clubs of New Jersey occupied the campsite for two weeks. Staff was brought in early to accommodate the group. One of the staffers brought in early was the author's maternal grandmother, Frances Schoeler, standing upper right in white, who was a cook. (Courtesy of Dennis McDonald.)

Several celebrities have visited Camp Ockanickon over the years. Thirty-five-year-old Buddhist monk Thích Nhất Hạnh from Vietnam, second from right, was the guest speaker at Camp Ockanickon during the summer of 1962. At left is camp director William Douglass. Hanh has authored numerous books on Buddhism and is known as the "father of mindfulness." His stay at Camp Ockanickon was written about in *Fragrant Palm Leaves*. (Courtesy of the YMCA in the Pines.)

In July 1984, First Lady Nancy Reagan visited Camp Ockanickon and Camp Matollionequay. She spent the day touring the camp, lunching with the campers, riding in a rowboat, and enjoying songs from the campers. Her escorts were Scott Mandel of Cherry Hill, New Jersey, and Jayme Taylor of Indianapolis, Indiana, who sat beside her. (Photograph by Dennis McDonald, courtesy of the *Burlington County Times*.)

Seven

WOODFORD CEDAR RUN WILDLIFE REFUGE

Nestled among intertwined sand roads, pitch pines, and sparkling cedar lakes is one of New Jersey's most important resources: Woodford Cedar Run Wildlife Refuge. From flying squirrels to great horned owls, black snakes, and red foxes, licensed rehabilitators provide care to injured or orphaned animals. In total, over 6,300 wild animals of 150 species enter Cedar Run's Wildlife Rehabilitation Hospital annually.

Cedar Run's history began with Elizabeth "Betty" Woodford (née Miner). Born in 1916, Betty attended business school and worked as a stenographer while raising two children, Richard and Jeanne. With her children in school, Betty completed a three-year program at the Barnes Horticulture School and studies at the Morris Arboretum.

In 1951, Betty and her family purchased 184 acres from Edwin and Mary Rodgers for vacationing. Known as the Braddock Mill Tract, the property maintains a unique history and ecology. Archaeology reveals Indigenous peoples first occupied the area. During the 19th century, William Braddock operated a mill directly west of present-day Cedar Run. Later, cranberry farmers operated around the property.

By 1956, Betty gained popularity speaking to women's groups about the Pine Barrens. The following year, the Woodfords permanently relocated to Cedar Run. Betty and her husband, James "Jim" Woodford, began hosting groups to the property and assisting local residents with wildlife issues. Over the next two decades, the Woodfords created a sanctuary for injured and orphaned animals.

Outreach and education came to define Betty's life mission. She often appeared on television or radio shows, wrote articles for local news outlets, and taught Pine Barrens classes at Lenape High School and local colleges. Betty also lobbied politicians for wildlife protection legislation.

Today, Cedar Run honors Betty Woodford's vision and dedication. Woodford Cedar Run Wildlife Refuge's Rehabilitation Hospital is open seven days a week, 365 days a year, to offer critical care to New Jersey's wildlife. Serving as a community resource to the public, the wildlife hospital receives over 17,000 phone calls annually. Visitors can attend nature center programs, hike nature trails, and enjoy meeting 50 nonreleasable resident animals that reflect New Jersey's fauna.

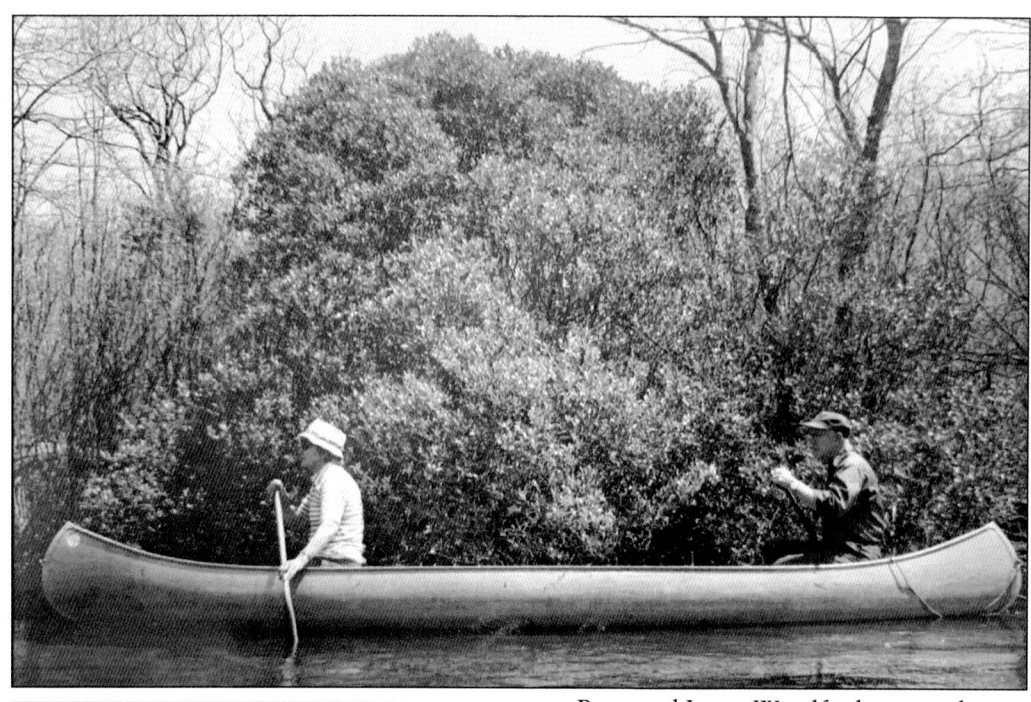

Betty and James Woodford, pictured here canoeing on a Pine Barrens stream, operated Cedar Run for nearly four decades. James constructed or supervised much of Cedar Run's facilities. Jeanne Woodford considered James the "brawn behind my mother's ideas." James served in the US Navy from 1944 to 1946, taught at Lenape High School for 22 years, managed the Burlington County Farm Fair for 15 years, ran Future Farmers of America, and was involved in the Medford Historical Society. (Courtesy of Jeanne Woodford.)

Shortly after purchasing Cedar Run, Betty Woodford created floral arrangements using native pinelands plants. She entered her arrangements in contests, including the 1955 New Jersey State Federation of Women's Clubs flower show, where she won second place. Pictured here in 1982, Betty showcases her handiwork. (Photograph by Dennis McDonald, courtesy of the *Burlington County Times*.)

Elizabeth Woodford is shown up close with a skunk in 1976. She recalled years after founding Cedar Run Wildlife Refuge that "we didn't plan on taking care of animals. Neighbors just begun bringing us animals who needed help. Two raccoons, who were creating a nuisance around a farmer's barn, were the first to arrive." As her reputation grew in the community, neighbors dropped off other four-legged critters, like this skunk. (Photograph by E.W. Faircloth, courtesy of the Burlington County Times.)

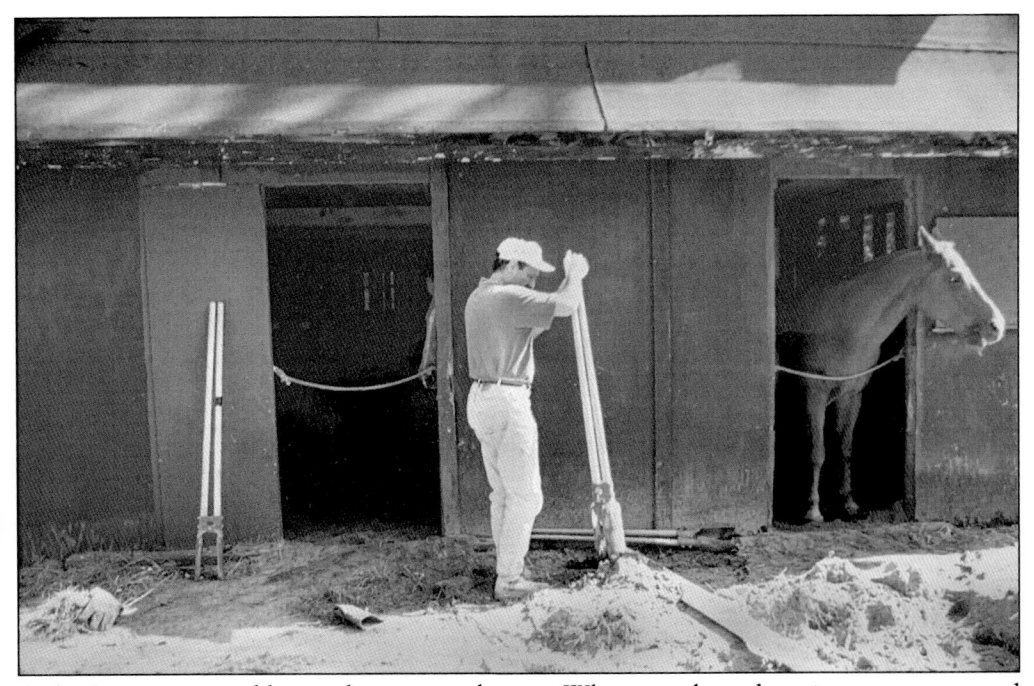

Cedar Run maintained horses during its early years. What was a horse barn is now a storage and feed barn. Behind the barn, the pasture horses once used is fenced off from public access. The area has enclosures for hospitalized animals that will eventually be released to the wild. (Courtesy of Jeanne Woodford.)

Teddy Roosevelt

Conservation Award

in recognition of outstanding
accomplishment and achievement
in the areas of conservation and wise
stewardship of natural resources
October 1, 1992

In 1976, the National Humane Society awarded Betty Humanitarian of the Year for her wildlife advocacy efforts. She is pictured with her plaque. Betty's achievement represents a long history of female reformers. Environmental professor Nancy Unger demonstrates that it was "homemakers" like Woodford that made "environmental issues as part of their rightful sphere and to include environmental activism in their various individual, club, and volunteer activities." Woodford's work coincided with women nationwide leading similar community conservation efforts that sparked the modern environmental justice movement of the 1960s and 1970s. In October 1982, Pres. George H.W. Bush bestowed the Theodore Roosevelt Conservation Award on the Woodfords and their Cedar Run Wildlife Refuge. US representative H. James Saxton nominated Cedar Run for the award. (Both, courtesy of Jeanne Woodford.)

In October 1979, *Burlington County Times* photographer Nancy Rokos traveled to Cedar Run Wildlife Refuge to document a meeting between Elizabeth Woodford and Sierra Club president Theodore "Ted" Snyder. Above, Elizabeth and Snyder walk along the edge of Cedar Run Lake to get a glimpse of pinecones. Founded in 1892 by the renowned environmentalist John Muir, the Sierra Club quickly grew, becoming a nationwide environmental conservation group. Ted Snyder served as national president from 1978 to 1980. Below, Elizabeth Woodford shows Snyder an injured red-tailed hawk. (Both photographs by Nancy Rokos, courtesy of the *Burlington County Times*.)

Elizabeth Woodford meets with the president of the Sierra Club, Joseph Fontaine, left, in September 1981. Cedar Run Wildlife Refuge officially incorporated in 1981. (Photograph by James MacIntyre; courtesy of the *Burlington County Times*.)

The Woodfords maintained a passion for ornithology, or the study of birds, over many decades. In 1956, Betty and Jim operated a bird-banding station that helped identify and track birds for the US Fish and Wildlife Service. Jim would later go on to serve as treasurer for the Delaware Valley Ornithology Club. Jim Woodford is pictured outside the animal hospital with Betty and a barn owl. (Courtesy of Jeanne Woodford.)

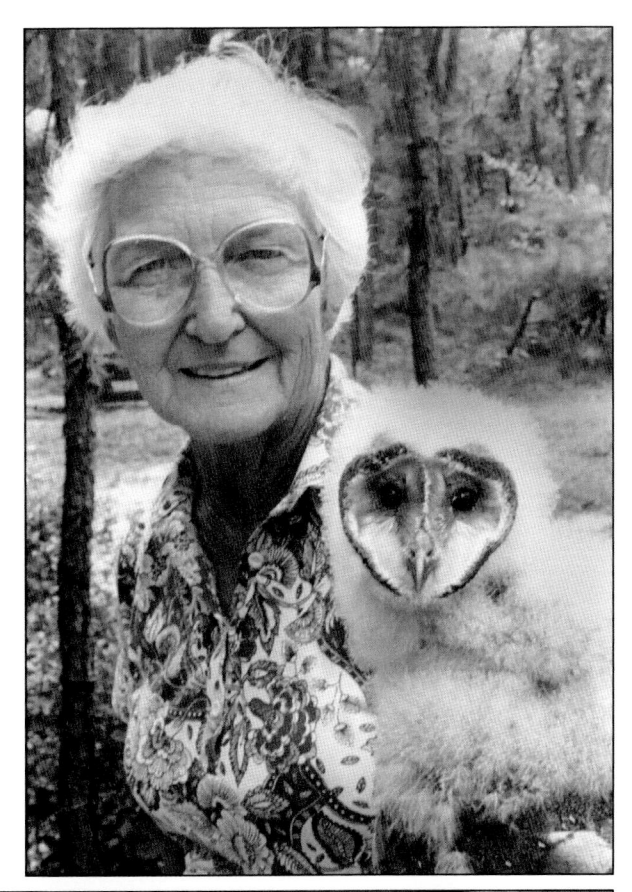

Photographer Rose Shields captures Betty Woodford holding an owl at an enclosure in Cedar Run. Betty's daughter, Jeanne, later recalled the origin of Cedar Run involved caring for a great horned owl. Woodford stated that "One day a friend brought us a great horned owlet which we began to feed with raw chicken, mice and roadkill. This was the beginning of wildlife rehabilitation for my folks and me. The owlet did quite well and was later released into the woods close to our home." Below, Betty Woodford shows visitors a sparrow hawk. (Right, photograph by Rose Shields; below, photograph by James MacIntyre; both, courtesy of the *Burlington County Times*.)

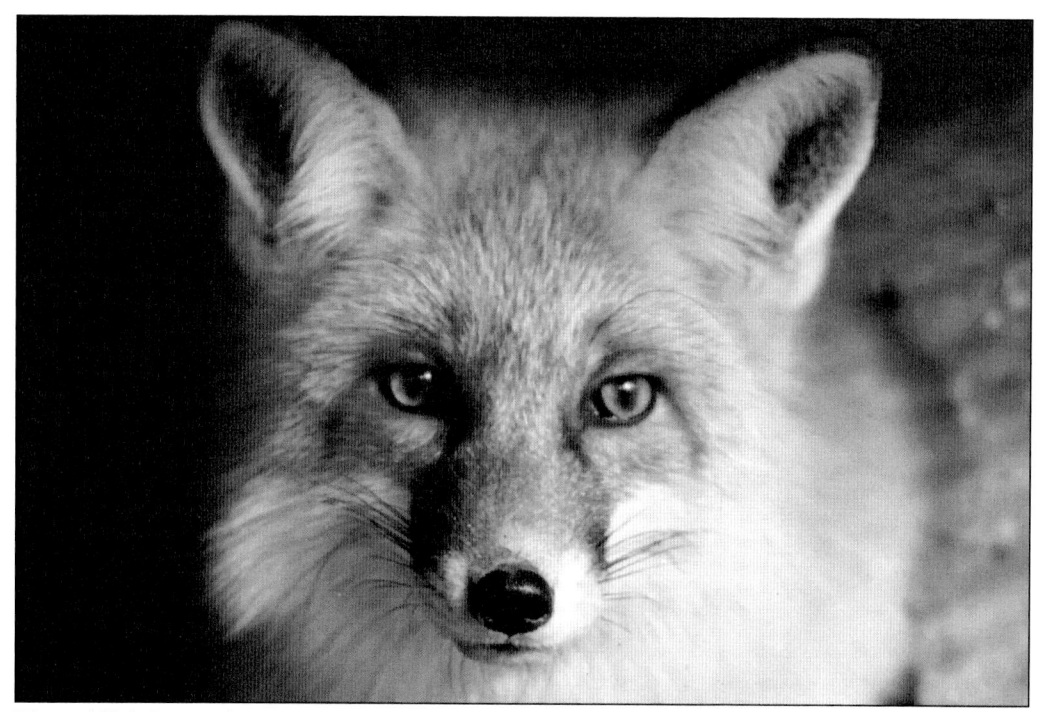

The wildlife hospital serves many animals, like the red fox pictured here. According to Jeanne Woodford, Foxy Lady was dropped at the hospital and had to remain as a permanent resident. Many animals that are too injured become permanent residents of the refuge. (Courtesy of Jeanne Woodford.)

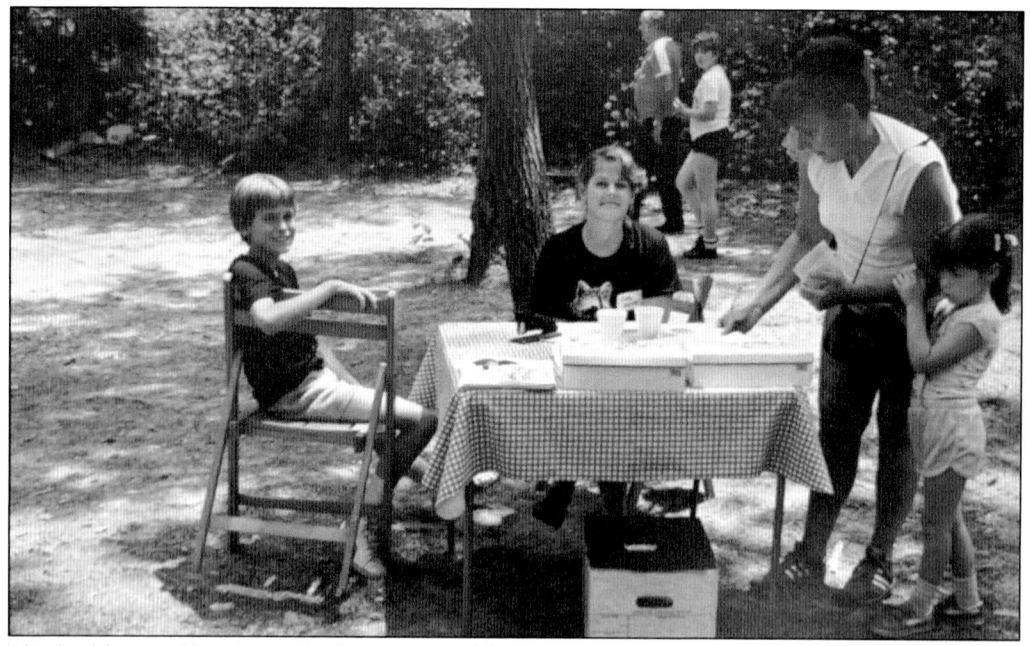

Elizabeth's granddaughter, Cindy, sits at a table during an open house event in 1986. Cindy and her mother, Georgia Wurster, lived at Cedar Run. Today, their former home serves as the nature center. (Photograph courtesy of Jeanne Woodford.)

In June 1990, a maelstrom precipitated Cedar Run Lake's dam to burst, draining the lake and forcing its waters into Kettle Run. The dam failure, shown above looking north near Sawmill Road, reveals the stumps of the cedar trees once harvested for processing in the adjacent sawmill. With the cedar trees removed, what had been a cedar swamp became Cedar Run Lake. Below, Jim Woodford operates an excavator as he repairs the dam at Cedar Run Lake in 1990. Woodford passed two years later at 81 years old. (Both, courtesy of Jeanne Woodford.)

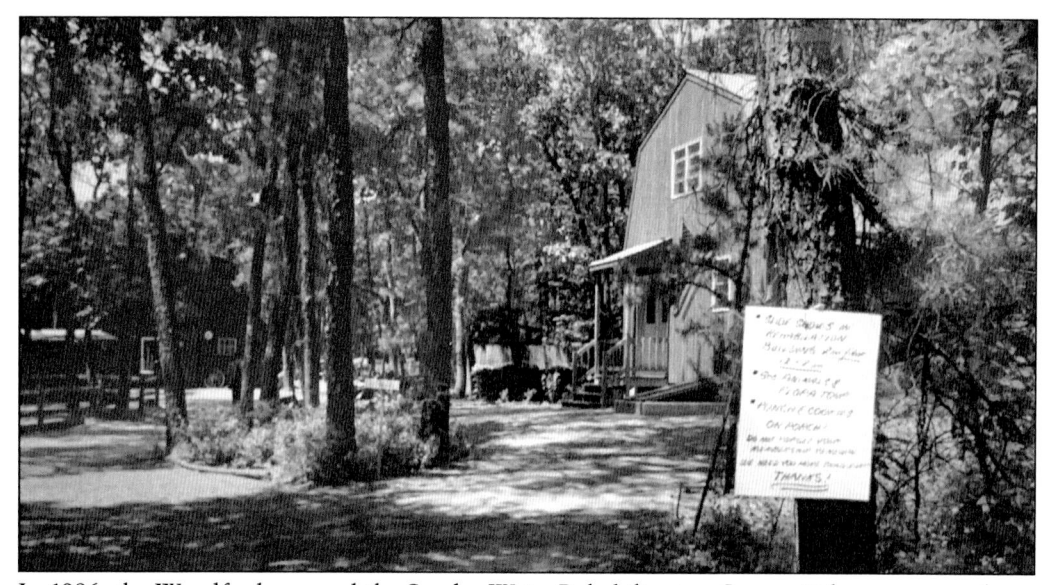

In 1986, the Woodfords opened the Sandra Weiss Rehabilitation Center. Taken two years later, this photograph shows the hospital, which remains in use today. An addition completed in 2015 created an animal reception area where the front porch once stood. The sign reads, "Slide Shows in Rehabilitation Building, 2nd floor, 12–2 pm, see animals and flora tour, punch, and cookies on porch. Do Not Forget your membership renewal—We need you more than ever, THANKS!" (Courtesy of Jeanne Woodford.)

While the name of this fawn is unknown, during a 1986 interview, Elizabeth Woodford told the story of a fawn named Sassafras that entered the hospital after being attacked by a wild dog. "When Sassafras was brought to us, he couldn't open his mouth . . . he wouldn't look at me. When animals are injured, they seem to develop a mute attitude, and he just stared in another direction. But he allowed me to feed him, and when the liquid wouldn't go down, he let me gently rub his throat." (Courtesy of Jeanne Woodford.)

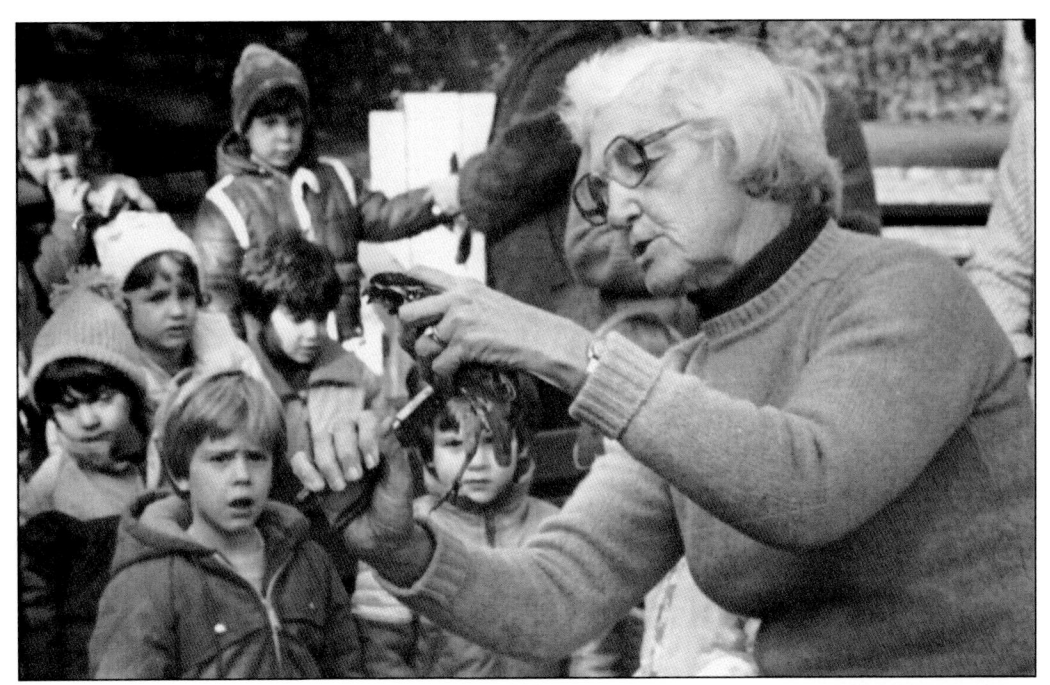

Above, Betty Woodford shows visitors a quail. Besides caring for animals, Betty believed deeply in the power of education. In a 1988 documentary, *My Pine Barrens Land*, highlighting Betty giving a Pine Barrens tour, she stated, "It's a personal pleasure knowing that they're learning something special that they might not have known. And the fact that it means more support for the Pine Barrens . . . it's just pure pleasure." At right, Betty Woodford feeds a baby raccoon, known as a kit. (Above, courtesy of Jeanne Woodford; right, photograph by Dennis McDonald.)

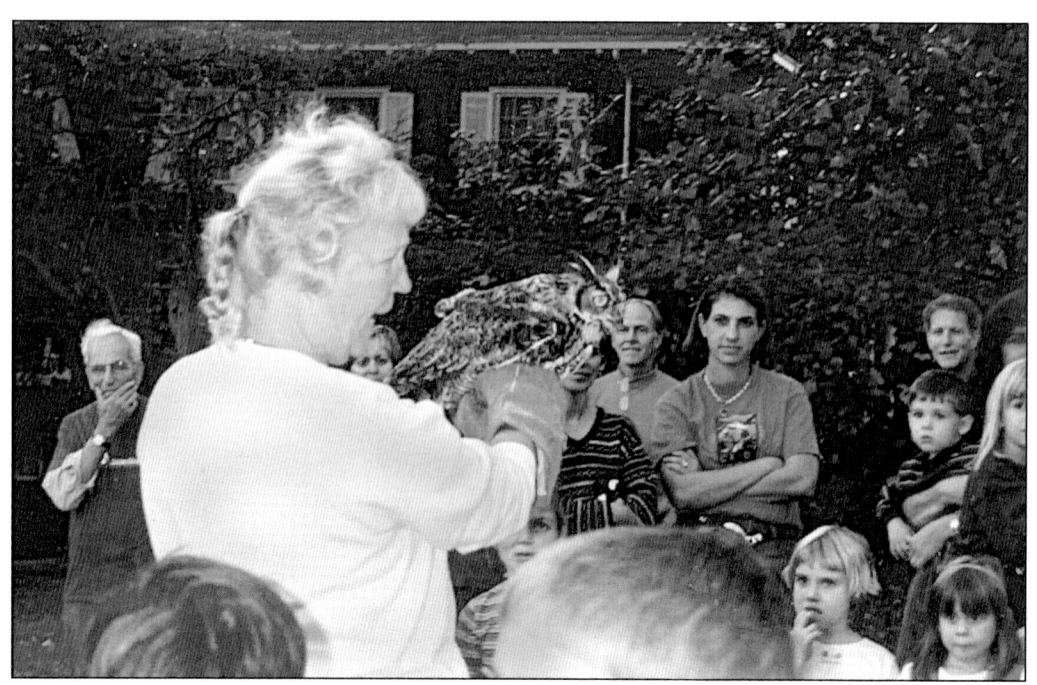

Above, Jeanne Woodford presents an owl to her audience. Woodford started her career as a special education teacher. As Betty's health issues increased toward the end of her life, Jeanne stepped in. Speaking of her passion for Cedar Run, Jeanne stated in an interview with *The Philadelphia Inquirer* in May 2000, "I love it as much as she did. I couldn't sleep at night if I did anything different." Below, Jeanne Woodford shows students an owl during a classroom presentation. (Both, courtesy of Jeanne Woodford.)

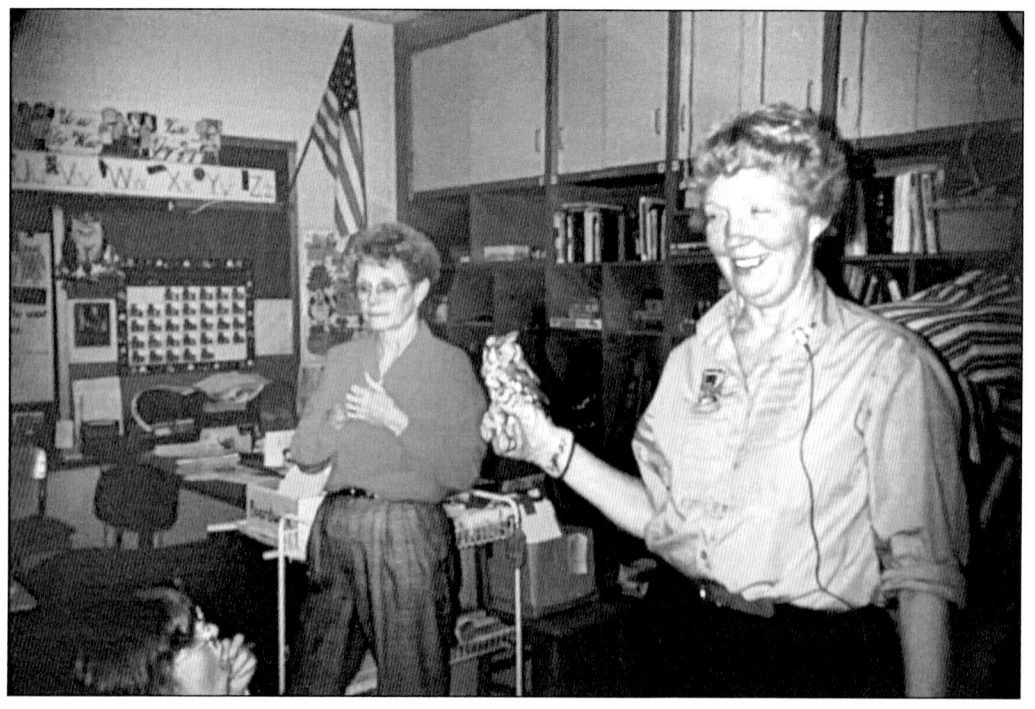

Eight

MEDFORD LAKES

On Friday July 15, 1927, Camden, New Jersey, real estate tycoon Leon Edgar Todd and his wife, Helen (née Cliver), embarked in an open-cockpit airplane from Camden to explore his new real estate venture in Burlington County known as Medford-Lakes-in-the-Pines. What began as a casual flight turned into a harrowing near-death experience. Todd miscalculated the mileage, and the plane exhausted its fuel while still 1,000 feet in the air! Their pilot, George Hand, skillfully landed the plane, saving the Todds and the Medford Lakes development that exists today.

For Todd's new venture, he joined forces with Clyde Arthur Barbour, a multimillionaire oilman and developer from Texas and New Orleans. In 1926, Barbour acquired vast stretches of land that belonged to the Ballinger, Lippincott, Miller, and Bowker families. The Medford Lakes Corporation formed, and Leon Todd later became the new community's public face.

Barbour and Todd's plan was ambitious. Their log-cabin-themed resort community involved transforming a vast pine forest containing cranberry bogs and Colonial-era landmark remnants like Charles Read's Aetna Furnace into 21 lakes and 1,600 building lots.

The late 1920s proved an excellent time for real estate. From the outset, residency demand ran exceptionally high. The Medford Lakes Corporation, for instance, sold 46 lots during just one September weekend. To establish Medford Lakes as a sociable community, Todd guided the creation of the Medford Lakes Colony Club in 1927.

Architect William H. Kenderdine helped Todd create a Maine aesthetic by providing future residents, referred to as "colonists," a choice between one- or two-story cabin designs made of cedar logs and containing large stone fireplaces. Like many planned communities of the era, deeds explicitly excluded African American and Jewish individuals from purchasing lots in the community through restrictive covenants.

The state legislature voted to create Medford Lakes Borough from Medford Township in 1939. As this chapter will demonstrate, Medford Lakes experienced significant growth during the post–Second World War era while preserving much of the community and natural aesthetic Leon Todd had envisioned.

BEFORE MEDF
LAKES COLO

To Medford

STOKES RD

KEY

1. Etna Furnace
2. Lower Sawmill (Upper Sawmill)
3. Springhouse
4. Blacksmith Shop
5. Old Frame Cottage
6. Gristmill
7. Company Store (brick-floored)
8. Charles Read House
9. Icehouse
10. Cranberry Pickers' Shop

In 1957, the prolific South Jersey writer Arthur D. Pierce published *Iron in the Pines*. Pierce lived on Natchez Trail in Medford Lakes Colony and was associate editor of *The Philadelphia Inquirer*. In his discussion of Aetna Furnace, Pierce included a map, which is updated and reprinted here to assist the reader. He mapped out the buildings surrounding Charles Read's furnace and forge

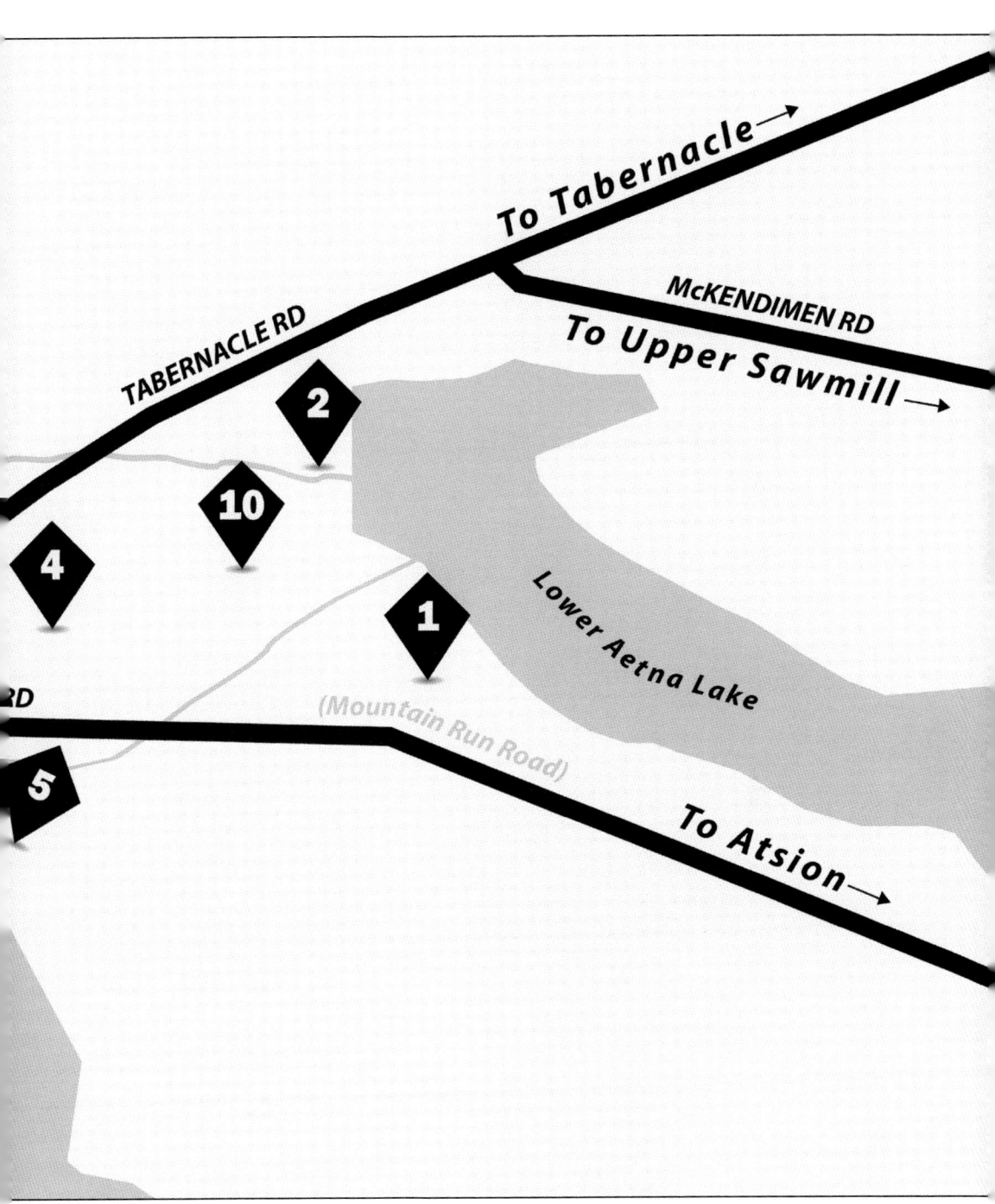

around 1770. The Read property at its height consisted of "9,000 acres with 'ore rights' to still other nearby lands," according to Pierce. (Copyright 1957 by Arthur D. Pierce. Renewed 1990. Reprinted by permission of Rutgers University Press.)

A cast-iron fireback forged in present-day Medford Lakes is on display in New York City's Metropolitan Museum of Art. In 1766, Charles Read III founded two iron works, Aetna and Taunton. Read named Aetna after the Roman god of metalwork's home, Mount Etna. Read employed both paid and enslaved labor to forge flatirons, wagon boxes, iron handles, and other items on the South Branch of the Rancocas Creek. The furnace closed in 1773. Today, Lower and Upper Aetna Lakes derive their names from the forge. (Courtesy of the Metropolitan Museum of Art.)

The former Charles Read house was located near the intersection of Stokes and Tabernacle Roads. Following Charles Read III's financial collapse and death in 1774, his son, Charles Read Jr., lived here with his wife, children, and three enslaved persons. During the American Revolution, Read Jr. served one month in the Continental Army's "Flying Camp," upon which he turned allegiances. Read Jr. was placed in jail for his traitorous act but eventually released. He lived at Aetna until his 1783 death. The building was torn down in 1959. (Courtesy of Brian Carns from the Mickle Collection.)

A group poses in a c. 1910 Ford Model T near the old store in Medford Lakes around 1914. The store was located near the current township garage on Stokes Road. Cranberry farmer Lewis King stands at left. Young teenage driver Reginald, son of farmer Joseph W. and Laura F. Ballinger, sits at the wheel. Ballinger's former boarder, Charles Dixon, stands on the right. His new wife, Mary Dixon (née Miller), is the middle of the three women. (Courtesy of Mark Scherzer from the Mickle Collection.)

A group portrait was taken near Stokes Road where Medford Lakes is now located. Two buildings exist in the background, a corn crib on the left and a barn on the right. Mary and Charles Dixon flank the left side. Reginald Ballinger is second from right. (Courtesy of Beverly Mickle.)

An unidentified woman stands in front of the old store and icehouse located on the west side of Stokes Road just north of Lenape Trail in what is now Medford Lakes. Prior to Clyde A. Barbour and Leon E. Todd's acquisition of the area, it comprised barren, sandy land with scattered cranberry bogs. (Courtesy of Beverly Mickle.)

Joseph and Laura Ballinger's daughter, Helen, poses with Robert Norman Henderson looking up Lenape Trail from Stokes Road. In June 1917, two months after the United States entered World War I, Robert registered for the draft. One month later, Robert and Helen married in Camden. This photograph was likely taken on or around their wedding day. Following Robert's military service, the couple bought a home in Medford On the 1928–1929 Medford-Lakes-in-the-Pines map published by the Medford Lakes Corporation, Lenape Trail was not yet developed as a road with cabins. Today, Lenape Trail is one of the main throughfares through Medford Lakes Borough. (Courtesy of the Mickle Collection.)

Raised in Haddonfield, Michael Eberly Vail Levinsky moved to Medford Lakes in 1980 and quickly fell in love with the community. In 1982, she was elected to the town council and became Medford Lakes first female mayor from 1986 to 1990, serving two terms. As mayor, she initiated a bike path along Tabernacle Road, the recycling center, and the Historic District and Preservation Commission. She is shown here at a Memorial Day ceremony. (Photograph courtesy of David Levinsky.)

Leon Todd and his wife, Helen M. Cliver, are pictured prior to taking off near Camden to observe Leon's newest real estate investment. Born in 1894 to parents Linwood and Ida May, Todd graduated from the Pierce School of Business Administration in Philadelphia in January 1915, and by February, he married his childhood sweetheart. After their honeymoon in Atlantic City, the newlyweds moved into their home at 321 North Forty-Second Street in Camden, New Jersey. Three years later, in 1918, Todd's career skyrocketed when he purchased James K. Asay's real estate business. He focused the business on the booming property market of Camden's East Side. By his death in 1959, Todd was a force in the real estate world, serving as president of the Camden County Board of Realtors, New Jersey Real Estate Boards, and New Jersey Real Estate Commission and vice president of the National Association of Real Estate Boards. (Courtesy of Mark Scherzer from the Mickle Collection.)

This sign marked the entrance to the Medford-Lakes-in-the-Pines Summer Colony. The sign, sitting along Stokes Road, says "Stop at the cabin for particulars." Prospective buyers crossed the "Bridge of Tradition" as they walked toward the cabin where the borough hall and police station are now located. Note the use of the word "colony" along with the emphasis on "tradition." (Courtesy of the Medford Lakes Colony/Clint Alexander Historic Museum Collection.)

The Medford Lakes Sales Office in 1928 was located at Hiawatha and Mohawk Trails. The creation of Medford Lakes as a log cabin summer resort, suffused with themes of Indigenous peoples and pioneers, reflects a growing 1920s trend of using a historic narrative as a marketing technique geared toward middle-class families. (Courtesy of the Medford Lakes Colony/Clint Alexander Historic Museum Collection.)

The freewheeling 1920s witnessed the rise of targeted advertising in both print and radio. Leon Todd's advertising team used current president Calvin Coolidge as a marketing technique, as seen in this Saturday, June 23, 1928, newspaper advertisement. Coolidge famously summered in log cabins on a lake to avoid the heat of Washington, DC, during his presidency. Newspapers in Philadelphia and Camden plus radio marketing played an important role in recruiting families to settle in the community. Beginning in 1930, WCAU Philadelphia ran a five-minute program called "Medford Lakes News." The broadcast brought attention to the nascent community. (Courtesy of the *Morning Post*.)

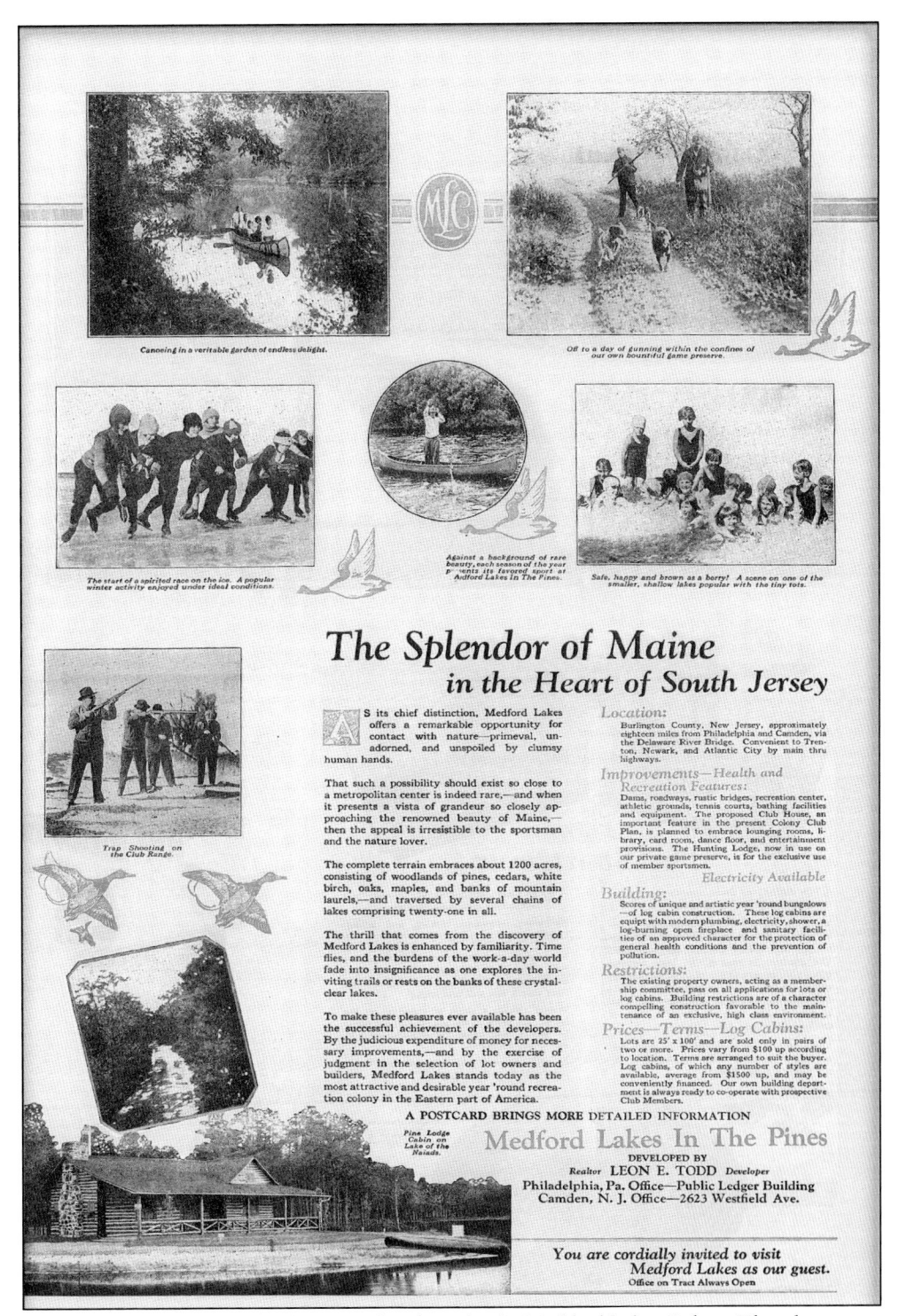

Canoeing in a veritable garden of endless delight.

Off to a day of gunning within the confines of our own bountiful game preserve.

The start of a spirited race on the ice. A popular winter activity enjoyed under ideal conditions.

Against a background of rare beauty, each season of the year presents its favored sport at Medford Lakes In The Pines.

Safe, happy and brown as a berry! A scene on one of the smaller, shallow lakes popular with the tiny tots.

Trap Shooting on the Club Range.

The Splendor of Maine
in the Heart of South Jersey

AS its chief distinction, Medford Lakes offers a remarkable opportunity for contact with nature—primeval, un-adorned, and unspoiled by clumsy human hands.

That such a possibility should exist so close to a metropolitan center is indeed rare,—and when it presents a vista of grandeur so closely ap-proaching the renowned beauty of Maine,—then the appeal is irresistible to the sportsman and the nature lover.

The complete terrain embraces about 1200 acres, consisting of woodlands of pines, cedars, white birch, oaks, maples, and banks of mountain laurels,—and traversed by several chains of lakes comprising twenty-one in all.

The thrill that comes from the discovery of Medford Lakes is enhanced by familiarity. Time flies, and the burdens of the work-a-day world fade into insignificance as one explores the in-viting trails or rests on the banks of these crystal-clear lakes.

To make these pleasures ever available has been the successful achievement of the developers. By the judicious expenditure of money for neces-sary improvements,—and by the exercise of judgment in the selection of lot owners and builders, Medford Lakes stands today as the most attractive and desirable year 'round recrea-tion colony in the Eastern part of America.

A POSTCARD BRINGS MORE DETAILED INFORMATION

Location:
Burlington County, New Jersey, approximately eighteen miles from Philadelphia and Camden, via the Delaware River Bridge. Convenient to Tren-ton, Newark, and Atlantic City by main thru highways.

Improvements—Health and Recreation Features:
Dams, roadways, rustic bridges, recreation center, athletic grounds, tennis courts, bathing facilities and equipment. The proposed Club House, an important feature in the present Colony Club Plan, is planned to embrace lounging rooms, li-brary, card room, dance floor, and entertainment provisions. The Hunting Lodge, now in use on our private game preserve, is for the exclusive use of member sportsmen.

Electricity Available

Building:
Scores of unique and artistic year 'round bungalows —of log cabin construction. These log cabins are equipt with modern plumbing, electricity, shower, a log-burning open fireplace and sanitary facili-ties of an approved character for the protection of general health conditions and the prevention of pollution.

Restrictions:
The existing property owners, acting as a member-ship committee, pass on all applications for lots or log cabins. Building restrictions are of a character compelling construction favorable to the main-tenance of an exclusive, high class environment.

Prices—Terms—Log Cabins:
Lots are 25' x 100' and are sold only in pairs of two or more. Prices vary from $100 up according to location. Terms are arranged to suit the buyer. Log cabins, of which any number of styles are available, average from $1500 up, and may be conveniently financed. Our own building depart-ment is always ready to co-operate with prospective Club Members.

Pine Lodge Cabin on Lake of the Naiads.

Medford Lakes In The Pines
DEVELOPED BY
Realtor **LEON E. TODD** *Developer*
Philadelphia, Pa. Office—Public Ledger Building
Camden, N. J. Office—2623 Westfield Ave.

You are cordially invited to visit
Medford Lakes as our guest.
Office on Tract Always Open

While undated, this is an early advertising brochure for the Medford Lakes Colony. The advertisement demonstrates Leon Todd's vision of an exclusive, high-class, and community-oriented town based on outdoor recreational living. (Courtesy of Dennis McDonald.)

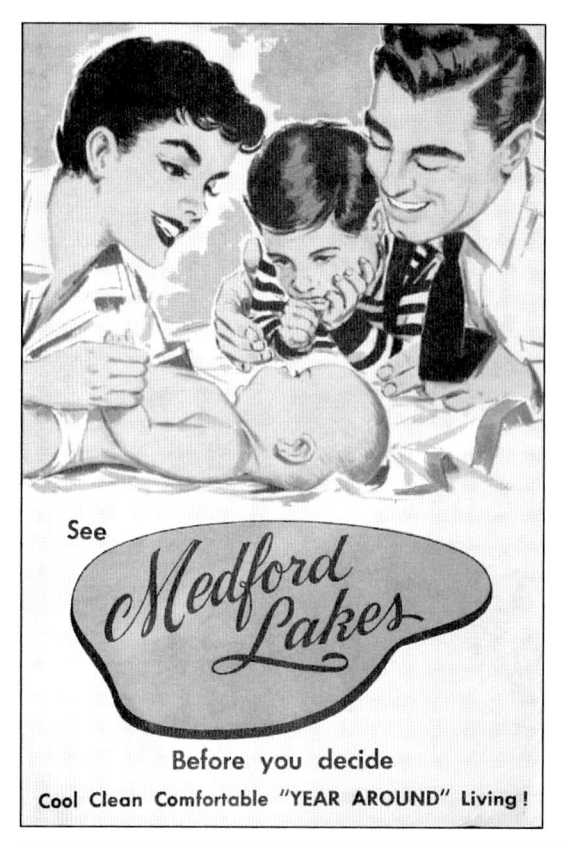

This advertisement brochure, showing a young white family on the front, represents Medford Lakes' primary appeal as a family resort. Inside is a map with images of various activities offered throughout the town, including Brooks Athletic Field, Beaches 1 through 4, and a country club. (Courtesy of Joan Lewis.)

This aerial photograph, taken in the 1930s, shows part of Medford Lakes, including Lower Aetna Lake and Beach 1. It also shows the Medford Lakes Golf Course in the upper left. The nine-hole course, designed by Alexander Findley, opened in 1930. In 1969, the course expanded to 18 holes. (Courtesy of Carl Pellegrino.)

Without the innovation of the motor vehicle, Medford Lakes would not be possible. Most advertisements offered roadway directions as the only efficient way to Medford Lakes from Philadelphia. Above is the intersection of Tabernacle and Stokes Roads looking south across Ballinger Lake. During the community's early days, Todd ran weekly bus trips from Philadelphia and North Jersey to bring in prospective buyers. (Above, courtesy of Mark Scherzer from the Mickle Collection; below, courtesy of the Medford Lakes Colony/Clint Alexander Historic Museum Collection.)

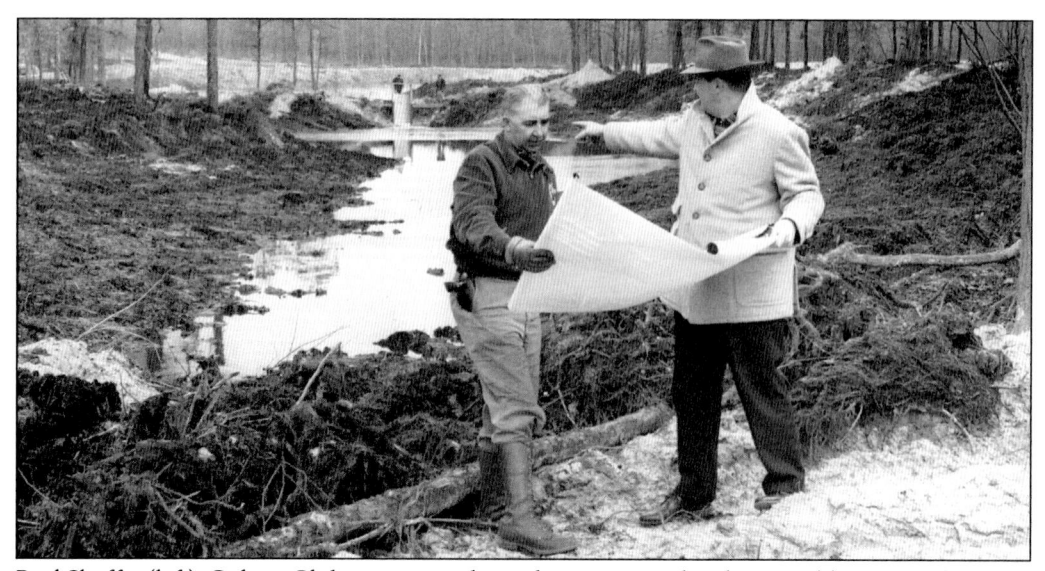

Paul Shaffer (left), Colony Club superintendent of property, and Jack W. Todd, Leon and Helen's youngest son, review plans for Lake Wabissi in 1956. What would become Lake Siquitise is in the background. Both were former cranberry bogs converted into recreational lakes. Wagush Trail follows the path of an old bog road or dike dividing Lake Wabissi and Lake Mishe Mokwa. (Courtesy of Mark Scherzer from the Mickle Collection.)

Sketch No. 1 from William H. Kenderdine of a Medford Lakes log cabin for Leon E. Todd Realty is dated October 1927. By the end of the next year, 58 cabins existed in Medford Lakes. Todd purchased Clyde Barbour's interest in the community in 1929, at which point 123 cabins existed. (Courtesy of Carol Latti.)

Five generations of the Todd family pose for a picture at Leon Todd's residence in 1944. From left to right are Leon's grandmother Anna Fox; Leon Todd; granddaughter Joan Todd (Lewis); oldest son, Harrison; and mother, Ida May Fox. One year prior, Leon and Helen lost their middle child, Leon Jr. He was killed in action during an invasion of Rendova Island (Solomon Islands) during the Second World War. After graduation from Gettysburg College in 1942, Leon Jr. enlisted in the Navy and attained the rank of ensign. (Courtesy of Joan Todd Lewis.)

Leon Todd appears with two of his grandchildren, Joan Todd (Lewis) and Pat Todd (Gaines), in a 1945 portrait. Joan Lewis recalled that every Sunday, her whole family ate dinner at her grandfather's house at 133 Stokes Road. The home, known as the Founder's Lodge, remained in the family until 1984, when it was sold to Carol Cox Latti. (Courtesy of Joan Todd Lewis.)

Jody Rivera's father George Charles Merkh and two of her uncles stand in front of her grandparents' home on Hiawatha Trail. Pictured from left to right are George, Walter John Merkh, and Alfred Robert Merkh. Jody recalls her uncle Walter and his practical jokes, which she remembers fondly. (Courtesy of Jody [née Merkh] and Mike Rivera.)

Opened in 1927, most Medford Lakes residents will remember the Tea Room under the ownership of Adels "Mom" Schaffhauser (née Bednarik), who took over in 1932. Born in Hungary in 1887, she married her husband, John, in 1907 and lived on Cambridge Street in Philadelphia before moving to Stokes Road in Medford Lakes. There, she became a fixture of the community, running the combination gas station and grocery store until 1961. She passed away in 1977 at 89 years old. (Courtesy of Mark Scherzer from the Mickle Collection.)

Outdoor activities played a central role in Medford Lakes community life. The Medford Lakes Colony Club Riding Academy opened in 1928 and offered rides for $1 per hour. This photograph was taken shortly after opening. After its closure in the early 1930s, the borough built storage garages on the lot. About that time, William Loeffler opened Tip-Top Riding Academy next door on Stokes Road in Medford, which provided horses for recreational rides, camps, and competitions. (Courtesy of the Medford Lakes Colony/Clint Alexander Historic Museum Collection.)

Medford Lakes beaches have always played a key role in uniting the community. In this early photograph, nine bathers sit on a canoe at Beach 1 in 1929. Notice that all the girls have bobbed hair, the iconic hairstyle of the 1920s. The Medford Lakes Colony Club emblem, adopted in 1928, is emblazoned on a few bathing suits. The building in the back at left is the counselor's cottage. (Courtesy of the Medford Lakes Colony/Clint Alexander Historic Museum Collection.)

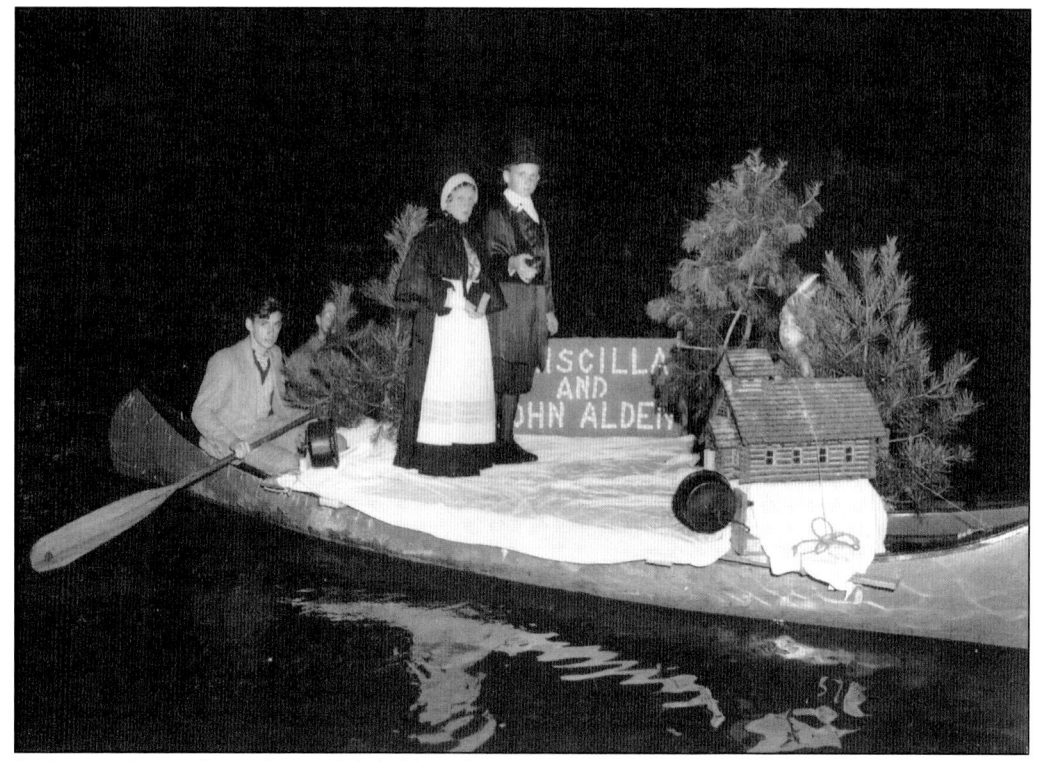

In August 1928, the Colony Club held its first Water Pageant on Lower Aetna Lake. The event, today known as the Canoe Carnival, involved a water parade of decorated canoes. This photograph comes from the 1936 Canoe Carnival. That year, over 10,000 people attended the event, witnessing many first-time features including music and fireworks. (Courtesy of the Medford Lakes Colony/ Clint Alexander Historic Museum Collection.)

In the summer of 1947, Medford Lakes held its second Water Pageant following a hiatus from 1942 to 1945 to preserve gasoline and supplies during World War II. Camden's *Evening Courier* reported that over 25,000 people attended the 16th-annual pageant. Former state assemblyman and then Colony Club president Harry A. Willson's float, named "Source of the Flying Saucer," won first prize. George Merkh and Harry Willson Jr. shot paper saucers from the float over the lake from a spring-activated cannon. (Photograph courtesy of Jody [née Merkh] and Mike Rivera.)

George Charles Merkh, the father of Jody Rivera, loved spending time on the lake. Here, George paddles his handmade canoe on Ballinger Lake. During warmer months, the Merkhs paddled across the lake to attend church at the Cathedral-of-the-Woods. Jody and her husband, Mike, were married at that church in 1994. (Photograph courtesy of Jody [née Merkh] and Mike Rivera.)

Today, most associate Medford and Medford Lakes baseball with coach Brian Anderson. However, baseball has always been an important part of Medford Lakes. This 1934 photograph includes, from left to right, (first row) Mitch Hopkins (umpire/part-time coach), Bud Tucker, Frank Loesch, Jim Bricker, Vern Hendrickson, and coach Phil Brooks; (second row) Joseph Heusser, Phil Brooks Jr., Jimmy Himmelein, Carlos Barolt, Clint Alexander, and Stan Alexander. (Courtesy of the Medford Lakes Colony/Clint Alexander Historic Museum Collection.)

George Robinson (left) and Leon Todd stand in front of the new Borough of Medford Lakes Administrative Building around 1939. In May 1939, New Jersey governor Arthur Harry Moore signed legislation incorporating Medford Lakes as a borough. The designation required the community to elect a mayor, council members, a tax assessor, and a tax collector. Todd ran unopposed and won the election with 119 votes out of 124 registered voters. (Courtesy of the Medford Lakes Colony/Clint Alexander Historic Museum Collection.)

Leon Gager and his wife, Helen (née Conway), are pictured in their log cabin at 124 Stokes Road. Leon Gager started his career as a police officer with Medford Township in 1929 before moving to Medford Lakes to become chief in 1939. He married Helen that same year. Leon served as police chief until 1971. (Courtesy of Ed Gager.)

In 1955, the Medford Lakes Board of Education approved the creation of its first elementary school. William Shine served as the school's first teaching principal and later superintendent. Pictured here is the first graduating class in 1957. The school would later be called School No. 1 and today is known as the Nokomis School. (Courtesy of the Nokomis School.)

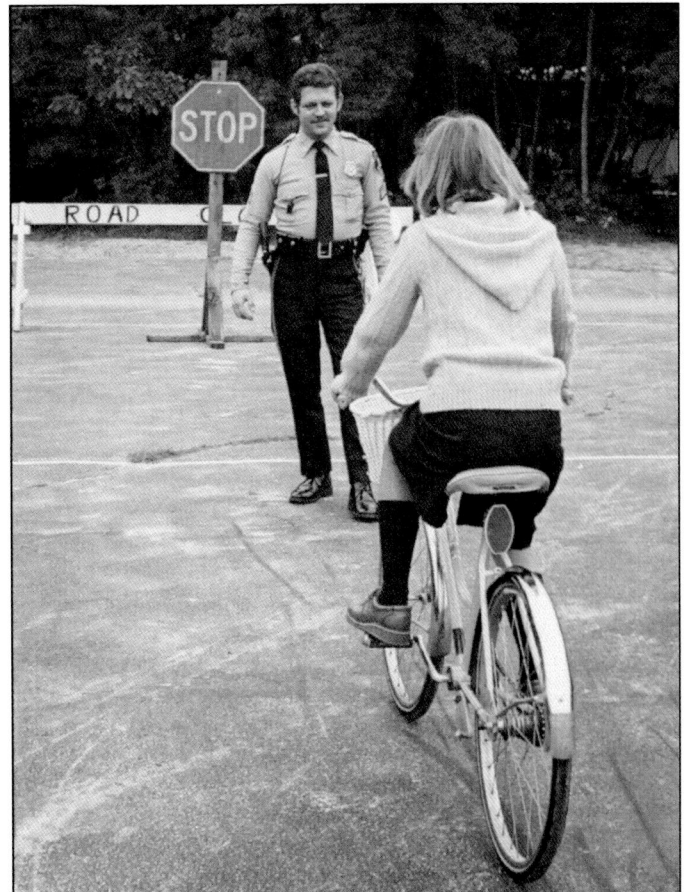

Medford Lakes police sergeant Jack Smith inspects bicycles outside Neeta School in 1978. For most Medford Lakes residents, bikes are an integral mode of transportation. To ensure bike safety, Medford Lakes police inspect bikes annually at the local schools. In 1960, Medford Lakes held its first Bicycle Safety Week to ensure mechanical safety and bike identification. (Courtesy of Jack Smith.)

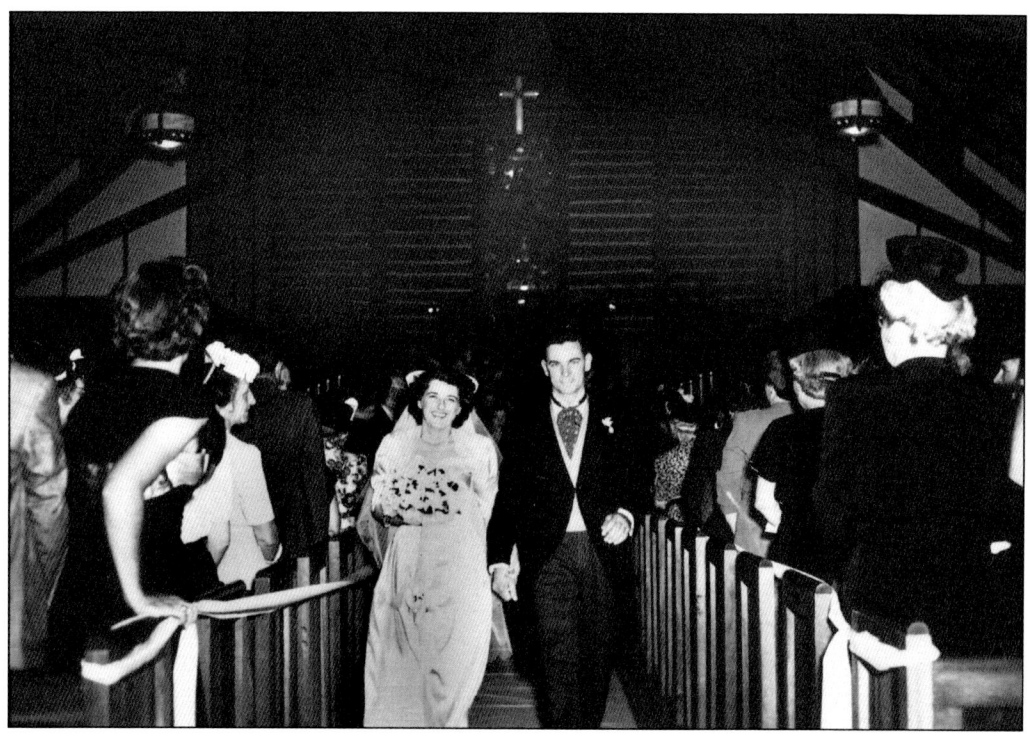

On Saturday, September 7, 1946, George Charles Merkh and Marian Willson married at the Cathedral-of-the-Woods. The new couple grew up around the corner from each other. Marian's parents, Harry A. and Elizabeth Willson, built Towhee Lodge on Mohawk Trail in 1938 as a summer escape from their residence in Merchantville, New Jersey. George's parents, John and Lydia Merkh, moved from Camden to Hiawatha Trail in 1941. (Courtesy of Jody [née Merkh] and Mike Rivera.)

Following the wedding ceremony, the Willsons held a reception at Towhee Lodge on Mohawk Trail. Here, Marian throws a bouquet of gardenias and stephanotis from the cabin's balcony to the unmarried female guests. She taught at the Nokomis School in Medford Lakes. (Courtesy of Jody [née Merkh] and Mike Rivera.)

Harry A. Willson and Elizabeth gave George and Marian a building lot on Natchez Trail as a wedding gift. They contracted with Mancil R. Gager, Medford Lakes' most prominent log cabin builder, to construct their new cabin. Per Medford Lakes custom, the first cabin on a street could be named a lodge. As a result, the Merkhs named their cabin at 39 Natchez Trail Natchez Lodge. (Courtesy of Jody [née Merkh] and Mike Rivera.)

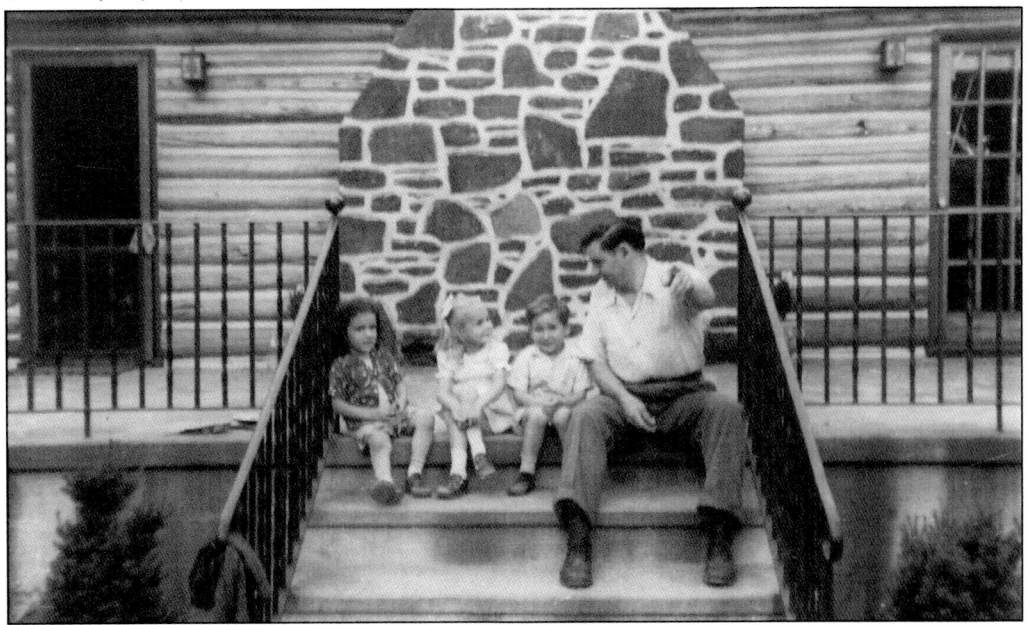

George Merkh and his three children sit on the steps of 39 Natchez Trail. From left to right are Jody (1949), Mimi (1955), and George Jr. (1948). Jody grew up to be a successful artist known for her detailed depictions of nature. Among the many treasures Jody has from her parents' cabin is the dining room table and bench that Mancil Gager built from the excess logs when building their log cabin. (Courtesy of Jody [née Merkh] and Mike Rivera.)

The Log Cabin Lodge, later known as the Settler's Inn, opened in August 1930. Leon Todd's development company operated the lodge to entice prospective buyers as they considered purchasing a cabin. The use of notched cedar logs and the large, 232-ton, 75-foot-high fireplace exemplified the 1920s architectural style known as National Park Service Rustic, which romanticized nature and the Western frontier. Renamed in 1976, the structure entered the National Register of Historic Places in 1982. On Saturday, January 10, 1998, at 4:30 a.m., a fire engulfed the Settlers Inn. The following day, wrecking balls razed the structure's remains. In 2000, P.J. Whelihan's purchased the lot, building a log-cabin themed restaurant that opened in May 2005. (Above, courtesy of Dennis McDonald; below, photograph by Dennis McDonald, courtesy of the *Burlington County Times*.)

Throughout its history, Medford Lakes has endured severe flooding, including in 1940. According to Leon Todd, that was Medford Lakes' "best summer." Labor Day weekend, however, proved an ignoble end. After 10 days of rain, a hurricane struck New Jersey, killing four and causing $4 million in damage. One of the deaths occurred near Medford and Medford Lakes. At right, on July 13 and 14, 2004, approximately 13 inches of rain ravaged South Jersey. Dubbed a "1,000-year storm," it broke dams, flooding Medford and Medford Lakes. Medford police sergeant and department emergency management coordinator Jeffrey Wagner managed the communication center for 28 hours straight. To ensure Medford Lakes residents never forget the flood, community members maintained the warped canoe that was found in that position after the flood. (Above, courtesy of Mark Scherzer from the Mickle Collection; right, photograph by Dennis McDonald.)

DISCOVER THOUSANDS OF LOCAL HISTORY BOOKS
FEATURING MILLIONS OF VINTAGE IMAGES

Arcadia Publishing, the leading local history publisher in the United States, is committed to making history accessible and meaningful through publishing books that celebrate and preserve the heritage of America's people and places.

Find more books like this at
www.arcadiapublishing.com

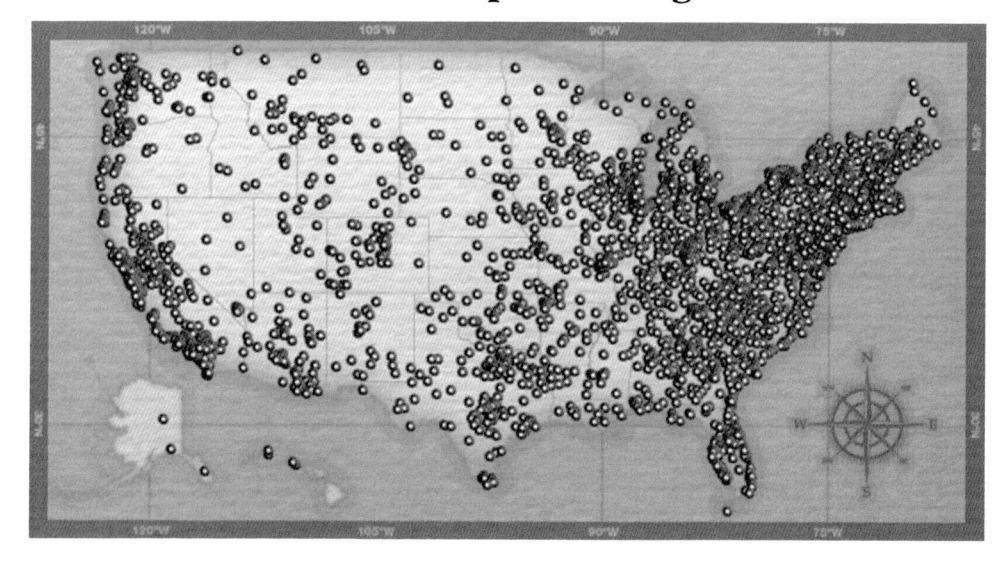

Search for your hometown history, your old stomping grounds, and even your favorite sports team.